MW00630404

IMAGES
of America

EAST HARLEM
REVISITED

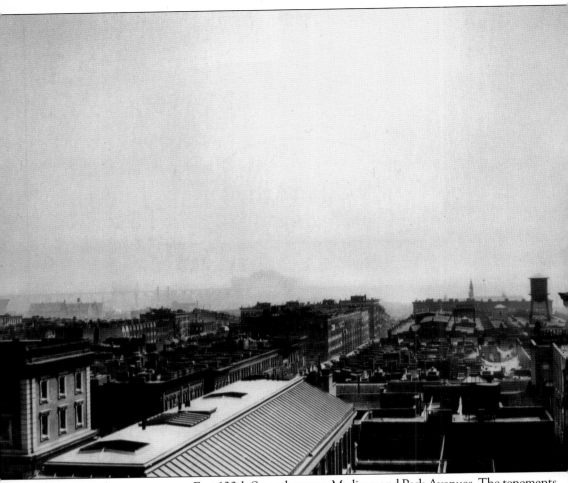

These are the tenements on East 100th Street between Madison and Park Avenues. The tenements also served as an open-air dryer as East Harlemites hung their clothes on the makeshift clothesline. The photograph was taken from the roof garden of the original Mount Sinai Hospital in 1922. (Courtesy of Mount Sinai Hospital.)

ON THE COVER: This is a view from inside the bocce court at the Benjamin Franklin Plaza cooperative on 106th to 109th Streets, First to Third Avenues. Please see page 39 for additional information. (Courtesy Theodore "Lionel" Baker.)

IMAGES
of America

EAST HARLEM
REVISITED

Best Wishes

Chris Bell

Christopher Bell

ARCADIA
PUBLISHING

Copyright © 2010 by Christopher Bell
ISBN 978-0-7385-7364-9

Published by Arcadia Publishing
Charleston, South Carolina

Printed in the United States of America

Library of Congress Control Number: 2010924256

For all general information, please contact Arcadia Publishing:
Telephone 843-853-2070
Fax 843-853-0044
E-mail sales@arcadiapublishing.com
For customer service and orders:
Toll-Free 1-888-313-2665

Visit us on the Internet at www.arcadiapublishing.com

Dedicated to Vincent Murphy, Wally Lambert, Manny Diaz Jr., and the people of East Harlem.

CONTENTS

ACKNOWLEDGMENTS

Thanks go to: Kathy Simko, Dr. Arthur Aufses Jr., Barbara I. Niss, Mount Sinai Hospital, Angela Bella Puco, Carlos De Jesus, Nicholasa Mohr, Ramon Ferreira, Manuel Diaz Jr., Leo Bailey, Millie Molina, New York City Housing Authority, Douglass DiCarlo, LaGuardia and Wagner Archives/ LaGuardia Community College, City University of New York, Jesús "Papoleto" Meléndez, Dimitrios Gatanas, Patricia Murphy, Olga Quiñónes, Rev. Norman C. Eddy, Vickie Beckford, Theodore "Lionel" Baker, John and Buffy Calvert, the Museum of the City of New York Print Archives, Manny Segarra, Wally Lambert, Ramon Rodriguez, John Torres, Catherine Brockington, and Ilona Albok Vitarius.

Unless otherwise noted, images are from the author's collection.

INTRODUCTION

East Harlem Revisited continues documenting the neighborhood's history through photographic images. Heartfelt thanks goes to Arcadia for publishing Images of America: *East Harlem* and for the many readers who bought the book. Seven years have passed since the publication of the first East Harlem book, and within that short period, the neighborhood has again grown in housing and population. The first chapter, called Rooftop Portraits, shows East Harlemites posing on the neighborhood's tenement rooftops. From 1890 to the 1950s, many neighborhood tenements lined East Harlem's streets, and East Harlemites ascended to the tenement's rooftops, which produced wonderful memories. For example, during the summer, East Harlemites and other city denizens slept, held cookouts, and flew kites, while other residents would take a blanket or bed sheet and spread it over the black tar roof. A plastic coating was applied to each tenement roof, and residents would sunbathe as if they were on the beach, hence the term tar beach. In short, these rooftop portraits became part of their family heirloom.

The second chapter, Diversity, profiles the many ethnic groups in East Harlem. At one time, East Harlem's population stood over 200,000 strong, with 35 different ethnicities and 27 different languages. Chapter three is called Neighborhood Landmarks/Neighborhood Name Change. The demolition of the old Pennsylvania Railroad Station in the early to mid-1960s led to the establishment of the New York City's Landmarks Preservation Commission in 1965. This commission is empowered to find and designate certain buildings and edifices throughout the city as landmarks for posterity. Since then, many buildings, churches, apartments, and banks have been saved from demolition long after they closed or stopped serving the public. However, parts of the neighborhood have been called something other than East Harlem. Some believe this choice is to embellish a certain part of the neighborhood while others believe it is done to separate itself from East Harlem's status as a working-class neighborhood. The fourth chapter, Reflections on Italian East Harlem, looks back at part of the neighborhood's history. From 1880 to 1950, thousands of Italian East Harlemites lived in the neighborhood and its unofficial boundary lines were 104–120th Streets and Third Avenue to the East River. At one time, East Harlem held one of the largest Italian communities in the country as an estimated 80,000 to 88,000 Italians lived in the neighborhood. Italian East Harlem declined after the anti-immigration statues of the early 1920s and declined even further during the Depression and post–World War II era. In 1950, Italian East Harlem stood at 50,000. The massive construction of public housing projects during the 1950s drastically reduced Italian East Harlem. By the late 1960s, only 10,000 to 12,000 Italians remained. Today an estimated 600 Italians live in East Harlem. Italian East Harlem is gone, but former Italian East Harlemites have maintained the traditions that took place in Italy or East Harlem like the Dancing of the Giglio and the Mount Carmel festival and today the father and son stickball league.

The fifth chapter, Famous People and Places, acknowledges the achievements of East Harlemites and the neighborhood's important places. The sixth chapter, Changing Scenes, looks back at several locations throughout East Harlem that have changed or remained the same and takes a deeper look at the tenements before they were demolished and replaced by public housing. The final chapter, Street Scenes, depicts the lives of everyday East Harlemites.

One

ROOFTOP PORTRAITS

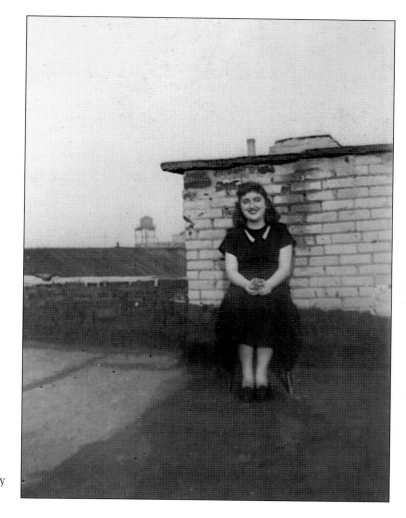

Calliope (Calageros) Gravanis reclines on a rooftop on 117th Street between First and Second Avenues in the 1950s. (Courtesy of Dimitrios Gatanas.)

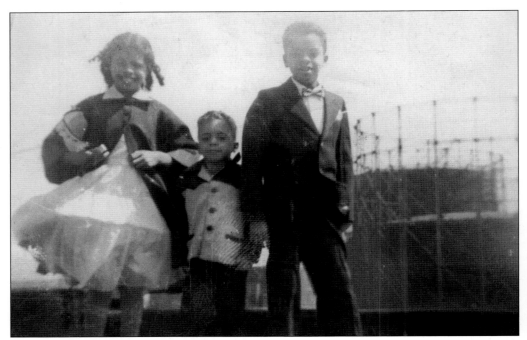

Jesus Papoleto Melendez poses with his brother and sister on their tenement rooftop on 109th Street and Third Avenue in the early 1950s. The water tank rising above the tenements was a common site in East Harlem before the construction of the public housing projects. (Courtesy of Jesus Papoleto Melendez.)

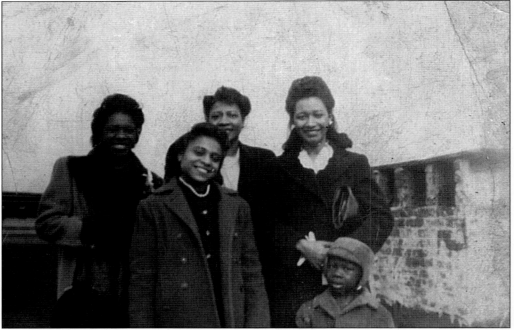

Anna Johnson, at far right, poses with friends and relatives on the 101st Street rooftop between Lexington and Third Avenues during the 1940s. (Courtesy of Leo Bailey.)

During the 1940s, an African American couple poses on an adjacent rooftop one block north on 102nd Street. (Courtesy of Leo Bailey.)

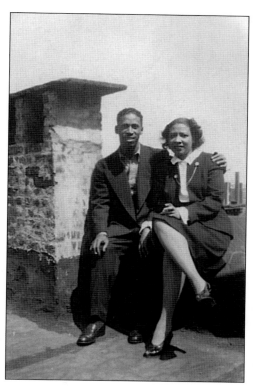

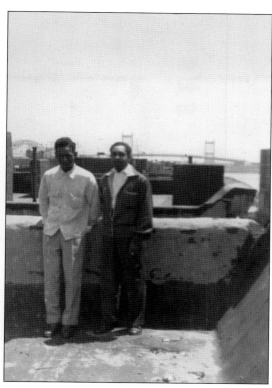

Victor Sanchez and his friend are shown standing on the rooftop at 100th Street between First and Second Avenues in 1953. The Robert F. Kennedy Bridge (formerly Triborough Bridge) can be seen in the distance. (Courtesy of Ramon Rodriguez.)

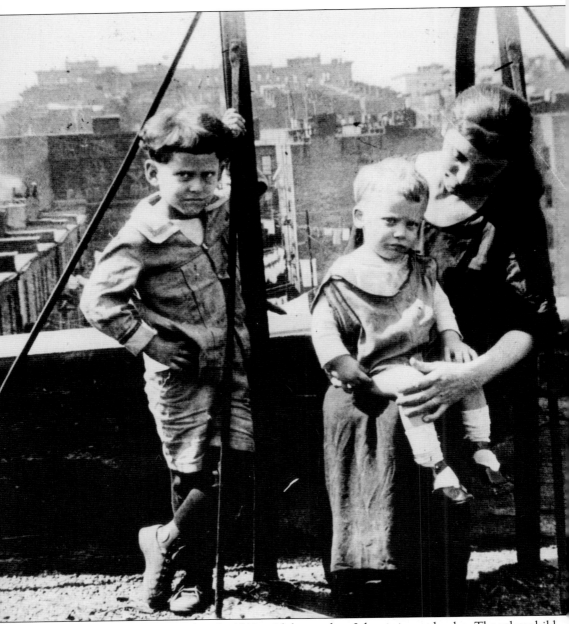

Librada Rodriguez is pictured in the 1940s with her nephew John sitting on her lap. The other child is unidentified. The location is 115th Street between Madison and Fifth Avenues. A clothesline can be seen in the distance. (Courtesy of Olga Quinones.)

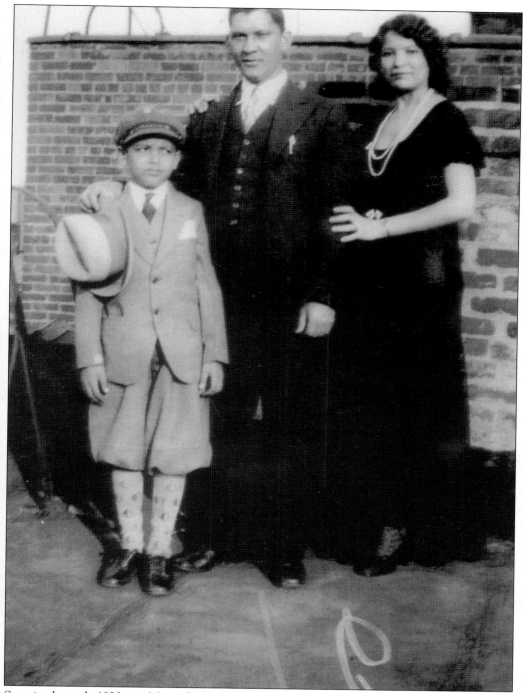

Seen in the early 1930s are Mr. and Mrs. Manuel Diaz Sr. with their son Manuel Diaz Jr. on their tenement rooftop located on 114th Street between Second and Third Avenues. (Courtesy of Manuel Diaz Jr.)

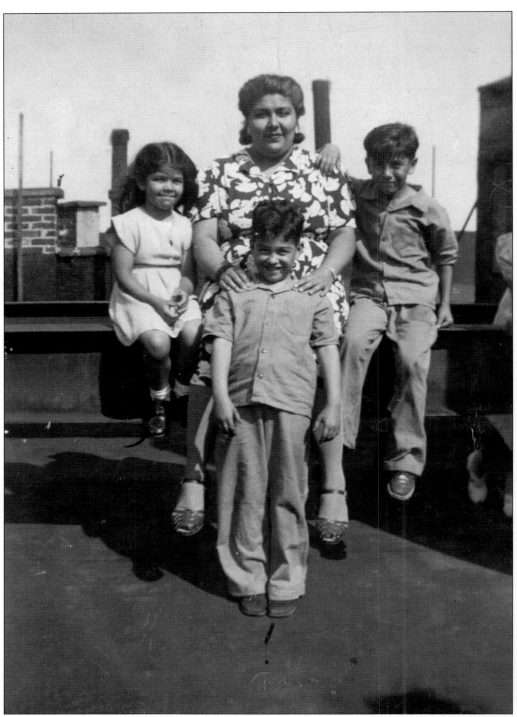

Luisa (last name unknown) poses in the early 1950s with her young relatives. Shown from left to right are Ester, Tony, and Peter on the rooftop of their apartment on 104th Street between Madison and Park Avenues. (Courtesy of Manny Segarra.)

In this faded early 1950s photograph, from left to right are unidentified, Carmen, Amarosa, and Manny Segarra (in front) on the roof of their apartment on 104th Street between Madison and Park Avenues. (Courtesy of Manny Segarra.)

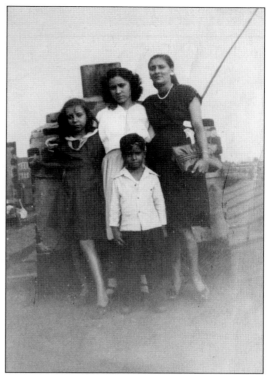

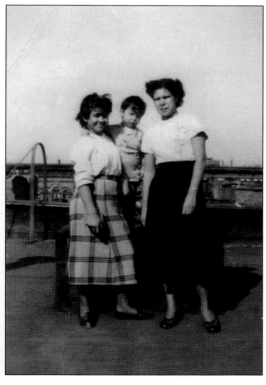

Esther and Ida Segarra are seen here on the same tenement building in the early 1950s. The child is unidentified. (Courtesy of Manny Segarra.)

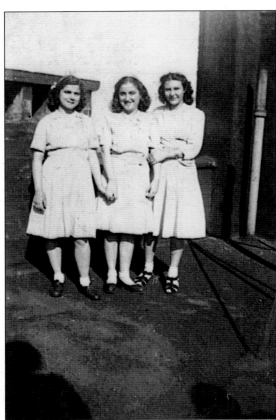

In the early 1950s, Calliope (center) poses with her sister Vasiliki (Calageros) Moudis (left) and Voula (last name unknown). (Courtesy of Dimitrios Gatanas.)

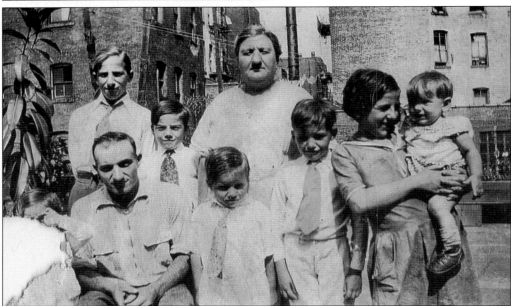

The Puco family poses on the roof of their apartment building located at 346 East 110th Street between First and Second Avenues in 1931. (Courtesy of Angela Bella Puco.)

16

Two

DIVERSITY

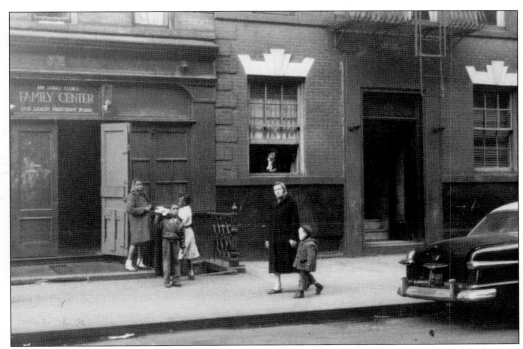

This early-1950s photograph represents the theme of this chapter of diversity as white, blacks, and Latinos are pictured in one image. The Reverend Peg Eddy is seen here with her son Timothy on their way to East Harlem Protestant Parish Family Center, located on 100th Street between First and Second Avenues. The African American youth and a Latino woman in the window are unidentified. (Courtesy of the Reverend Peg Eddy.)

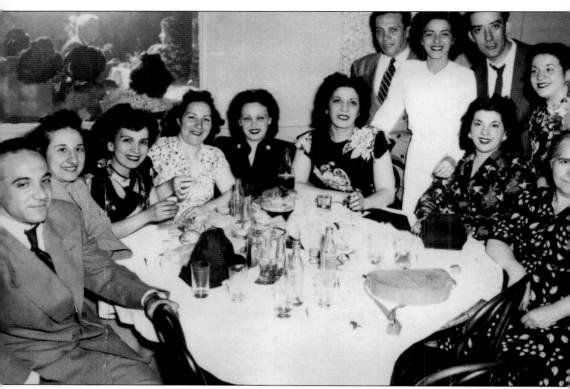

Italian East Harlemites attend an engagement party for Virginia Aiello-Mauro in 1949. From left to right are five unidentified, Caroline Pennino, an unidentified man, Columbia Pennino Altieri (in white), Anthony Altieri, Ida Altieri-Aiello (standing by Anthony), Virginia Aiello-Mauro, and Rose Puco. (Courtesy of Angela Bella Puco.)

This 1946 photograph shows East Harlem's own version of "Our Gang" from the *Little Rascals* series. Puerto Rican East Harlemites have gathered near East 110th Street for this picture. From left to right are (first row) Butchy (leaning on the rail), two unidentified, Jaime (Jimmy) Rodriquez, unidentified, Richie Rodriquez; (second row) Ramon Ferreira and George Buso; (third row) three unidentified ladies. (Courtesy of Ramon Ferreira.)

This time "Our Gang" is much smaller. Pictured in 1946 are, from left to right, unidentified, Jaime Rodriguez, unidentified, Johnny Moreno, Rich Rodriguez, George Buso, and Ramon Ferreira. The location is Lexington Avenue near East 110th Street. (Courtesy of Ramon Ferreira.)

In the early 20th century, many Puerto Ricans migrated to New York City by steamship. After their arrival, many Puerto Ricans settled in both East and West Harlem and in Brooklyn. Dominga Rodriguez de Velazquez is pictured on the second version of the steamship *Cuoamo* in 1930. (Courtesy of Manny Diaz Jr.)

Petrona Feliciano is seen in front of her apartment building on 80 East 116th Street in the 1930s. A replica of the original American flag is draped in the background. (Courtesy of Olga Quinones.)

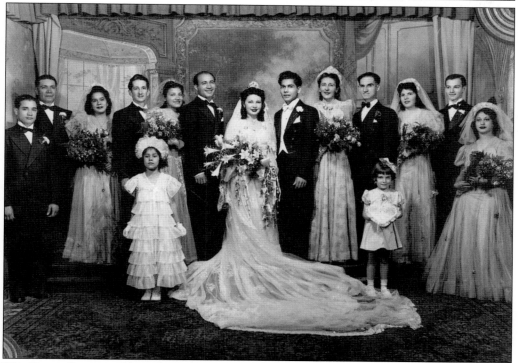

This Puerto Rican wedding photograph was taken June 14, 1940. Olga Quinones, fifth from left, attends the wedding of Luna and Carlos Fratechelli. (Courtesy of Olga Quinones.)

Mexican East Harlemites are seen taking their vows on 105th Street between Second and Third Avenues in 2005. A band is on hand to serenade the newlyweds.

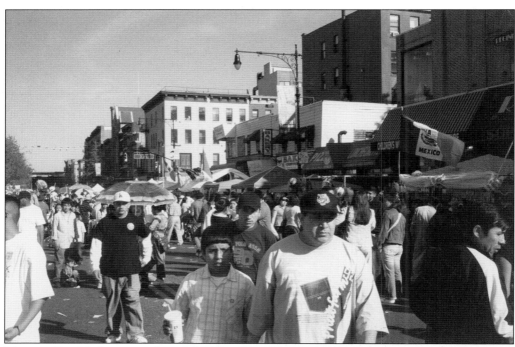

Mexican East Harlemites and many Mexican New Yorkers and their supporters celebrate el Cinco de Mayo (5th of May) in 2006. The festival spans two blocks from First to Third Avenues on 116th Street.

The Reverend Norman C. Eddy is seen in the early 1950s taking a stroll on East 100th Street between First and Second Avenues with his daughter Rebecca. (Courtesy of the Reverend Norman C. Eddy.)

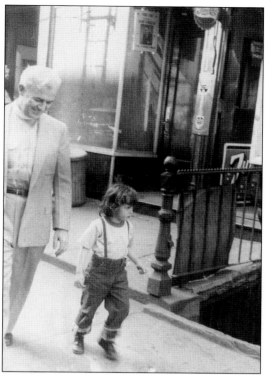

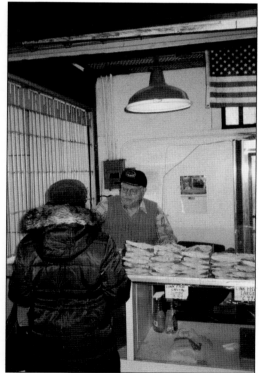

Jewish East Harlemite Bernard Lefcholz is pictured in 2008 at this fish stand, located on Park Avenue between 114th and 115th Streets inside La Marqueta. In its heyday, thousands of East Harlemites and other New Yorkers shopped at La Marqueta, where Lefcholz has been working for nearly 50 years.

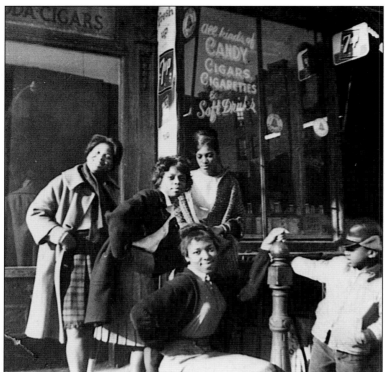

African American East Harlemites Victoria "Vickie" Beckford and friends pose in front of a local candy store on 130th Street and Madison Avenue in November 1962. (Courtesy of Vickie Beckford.)

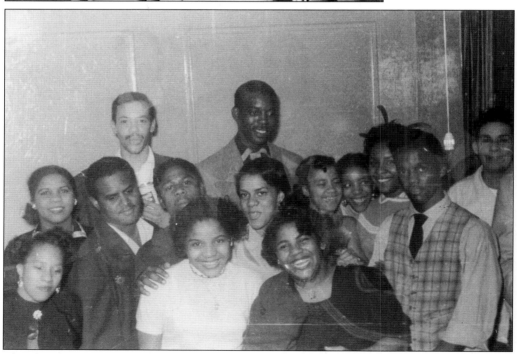

Theodore "Lionel" Baker, fourth from left, is seen in the early 1960s with friends in an apartment on 100th Street between First and Second Avenues. (Courtesy of Theodore "Lionel" Baker.)

In the early 1950s, a young African American mother is feeding her child in her apartment on 101st Street between Lexington and Park Avenues. (Courtesy of Leo Bailey.)

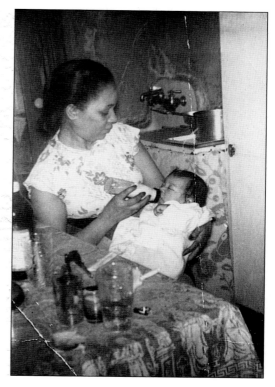

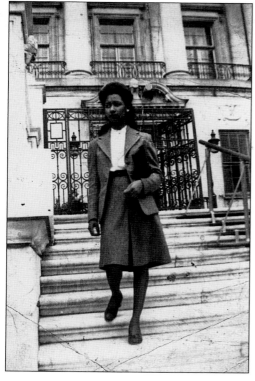

Anna Johnson is seen here leaving the Museum of the City of New York, which is located on 103rd–104th Streets and Fifth Avenue. The time is the early 1950s. (Courtesy of Leo Bailey.)

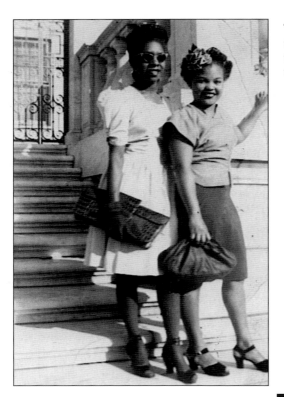

These African American women take their turn and pose for their portrait at the Museum of the City of New York in the early 1950s. (Courtesy of Leo Bailey.)

Seen here is Vincent Murphy, who lived with his family in East Harlem from 1921 to 1930. During this period, Murphy's father, Daniel Tade Murphy, worked at the Harlem Courthouse located on 121st Street between Lexington and Third Avenues. Many Irish, German, Eastern European Jews, and Italians lived in East Harlem during the early 20th century. (Courtesy of Patricia Murphy.)

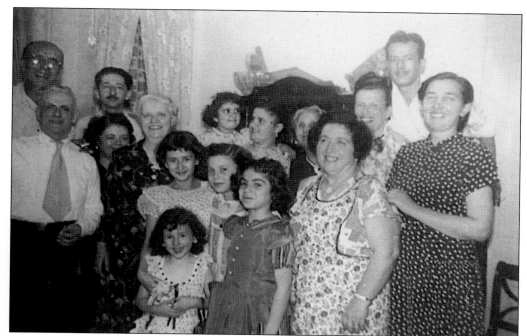

From the 1920s to the 1950s, Greek East Harlemites lived in several parts of the East Harlem neighborhood. Pictured are three generations of family gathering during the early 1950s. (Courtesy of Dimitrios Gatanas.)

Calliope (Calageros) Gravanis, third from left, and friends are seen at a birthday party in the early 1950s. The woman on Calliope's right, presumably the birthday celebrant, is seen here cutting her piece of cake. (Courtesy of Dimitrios Gatanas.)

Pictured here in the early 1950s with other celebrants are Vasiliki (Calageros) Gravanis, second from left; Calliope (Calageros) Gravanis, third from left; and Eleutherios Calageros, at far right. (Courtesy of Dimitrios Gatanas.)

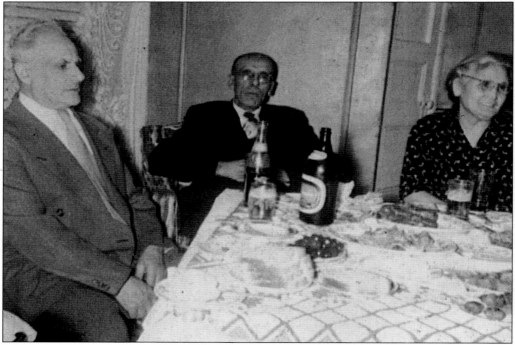

Pictured in the early 1950s sitting at the table are Eleutherios and Emily Calageros. The person in the middle is unidentified. (Courtesy of Dimitrios Gatanas.)

Three

NEIGHBORHOOD LANDMARKS/NEIGHBORHOOD NAME CHANGE

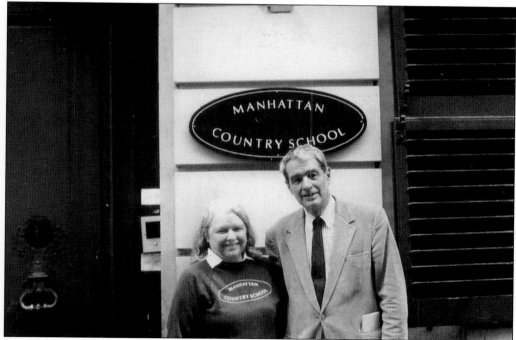

Seen in this 1997 photograph are Gus and Marty Trowbridge posing in front of the Manhattan Country School, formerly the Ogden Codman Jr. House. Since its founding in 1966, the Manhattan Country School has been in the forefront of providing a public education with a private school purpose. It also has a racially balanced enrollment of black, white, and Latino students.

This is the oldest house in East Harlem, at 17 East 128th Street between Fifth and Madison Avenues. Built in 1864, this two-and-half-story frame house was one of the earliest homes built in the neighborhood. One of the few remaining houses from that era, it was landmarked in December 1982. It is pictured here in 2004.

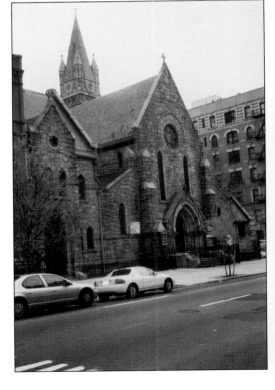

Saint Andrew's Episcopal Church, shown in 2004, is located on 127th Street and Fifth Avenue. The church was built by Henry M. Congdron from 1889 to 1890. It was landmarked in April 1967. For many years the church was segregated until African Americans were finally welcomed in 1943.

Saint Cecilia's Church is located on 106th Street between Park and Lexington Avenues. Napoleon Brun and Sons built it from 1883 to 1887. When the church was built, the neighborhood was dominated by German and Irish immigrants. Italians, Puerto Ricans, and now Mexicans continue the tradition of worshipping at the church. The church received landmarked status in December 1976. It is pictured here in 2004.

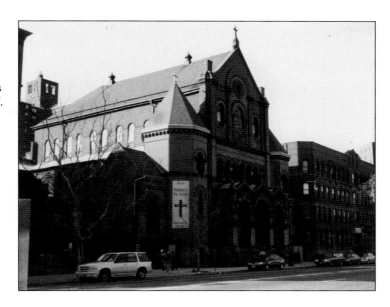

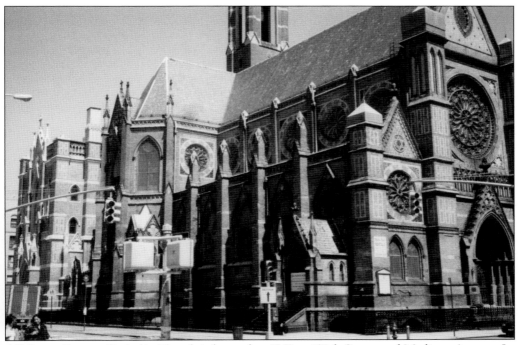

All Saints Roman Catholic Church is located at 47 East 129th Street and Madison Avenue. Its architect, James Renwick Jr., also designed Saint Patrick's Cathedral in midtown Manhattan. The church was built during the early 1880s and 1890s. Later a parish house and school were constructed. The original parishioners were Irish immigrants. Today African Americans and Nigerians worship at the church. It was designated a landmark in January 2007 and is pictured in 2004.

Erstwhile Engine Company 53 and the 28th Police Precinct were both located on 173–175 East 104th Street between Lexington and Third Avenues. In the late 1870s to early 1890s, New York City contracted Napoleon Le Brun and Sons to design over 40 firehouses for the city's fire department. The firehouse was built in 1883–1884 and closed in 1974. The police precinct was built in 1892–1893 by Nathaniel Bush. Later the 23rd Precinct operated at this location until 1973. Manhattan Community Access, a New York City cable station, is the current owner. The firehouse was landmarked in September 2008. An American flag is seen in the middle window on the third floor in this 1960s image. (Courtesy of the Calvert family.)

Fire Engine Company 36 was originally the Hook and Ladder Company 14. It was built in 1888–1889 by Napoleon Le Brun and Sons. Hook and Ladder moved to 2282 Third Avenue in 1975. That same year, Fire Engine Company 36 transferred to this location. Located on 120 East 125th Street between Park and Lexington Avenues, the firehouse closed in 2003. The former firehouse was landmarked in June 1997. It is pictured here in 2008.

McKim, Mead, and White architects built the 125th Street Library, which is located on 125th Street between Second and Third Avenues, in 1904 through the assistance of multimillionaire Andrew Carnegie. Carnegie donated over $5 million to New York City to construct numerous libraries throughout the five boroughs. Sixty-seven libraries were constructed from 1901 to 1929. It was designated a landmark in January 2008.

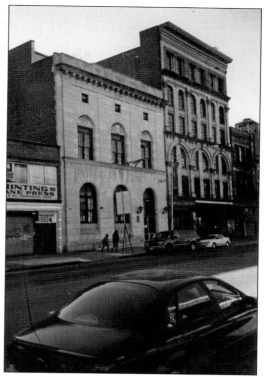

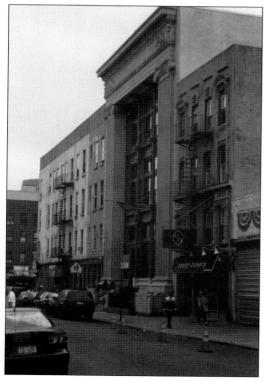

Aguilar Library is located at 172–174 East 110th Street and Lexington Avenue. The library was named after Grace Aguilar, a British author of Sephardic Jewish extraction. The library was built by Herts and Tallants in 1898–1899. It was renovated in 1904–1905 and again from 1993 to 1996. After its second renovation was completed, the library was designated a landmark that same year.

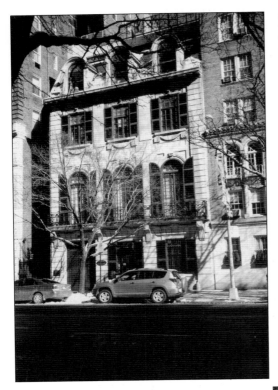

Manhattan Country School is located on 7 East 96th Street. The former Ogden Codman Jr. House was built in 1912–1913. It was bought by the schools' founders, Gus and Marty Trowbridge, in 1966 and received landmark status in May 1967.

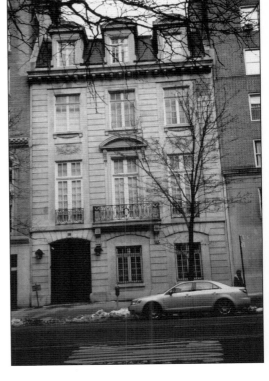

Lucy Dahlgren House is located few feet down from the school at 15 East 96th Street. Ogden Codman designed this house in the same style as the one he lived in. Built in 1915–1916, the house served as the home of Pierre Cartier, of the Cartier Jewelry fame. It received landmark status in 1984.

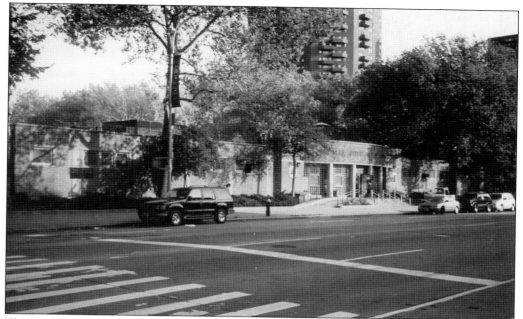

Thomas Jefferson Pool stretches three blocks from 111th to 114th Streets and First Avenue. The pool was built in 1936 during the Great Depression with the assistance of the federal Works Progress Administration. Architect Stanley Brogren, who worked for the city's parks department, designed it. The pool received landmark status in July 2007.

Residents who live in the southern part of East Harlem have adopted several names, such as the Upper East Side. Some believe it is to embellish this part of the neighborhood as opposed to East Harlem's status as a working-class community. This luxury apartment, located on Lexington Avenue between Ninety-sixth and Ninety-eighth Streets, follows the trend and is called Carnegie Hill Place.

Though it no longer exists, this cleaning company once located on Ninety-ninth Street and Third Avenue called itself Upper Yorkville Cleaners. The southern section of East Harlem has also been called Upper Yorkville.

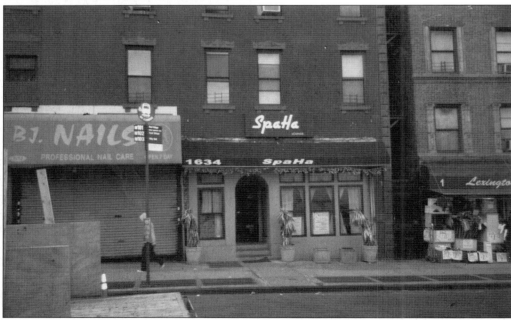

East Harlem became Spanish Harlem, or El Barrio, in honor of the many Puerto Ricans who have lived in the neighborhood. Today many people called the area "Spa Ha," short for Spanish Harlem. The Spa Ha Lounge, once located on Lexington Avenue between 103rd and 104th Streets, reaffirms the neighborhood's new name.

The Spa Ha Café continues this trend, as it is also located on Lexington Avenue near 116th Street.

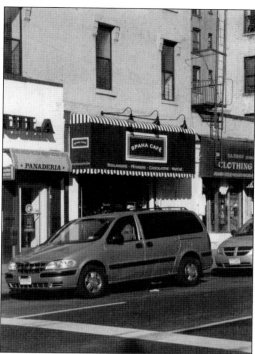

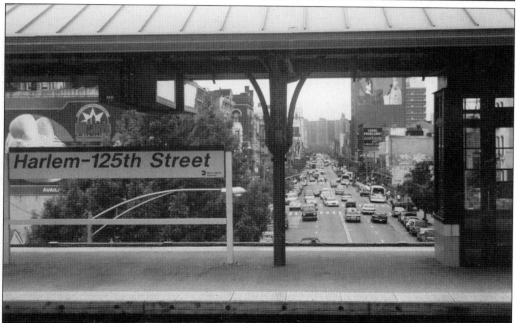

The 125th Street and Park Avenue Metro North Station is called Harlem. New Yorkers commonly refer to East Harlem as simply Harlem. Though it is part of the Harlem area, East Harlem's history is different from its two counterparts: West and Central Harlem. While the other two neighborhoods have been known for its historical black population and architecture, its East Side neighbor has been a transitional neighborhood.

The Harlem Children's Zone is located on East 125th Street and Madison Avenue. CEO Geoffrey Canada has been hailed as an innovator in education as the school prepares the next generation to succeed at the highest levels. The school received national recognition and was visited by Prince Charles in 2008. It is pictured here in 2005.

Owner Michelle Cruz of East Harlem Café prefers to keep the neighborhood's rightful name. Her establishment is located on 104th Street and Lexington Avenue and is a favorite place for East Harlemites to drink coffee or enjoy a light meal.

Four

REFLECTIONS ON ITALIAN EAST HARLEM

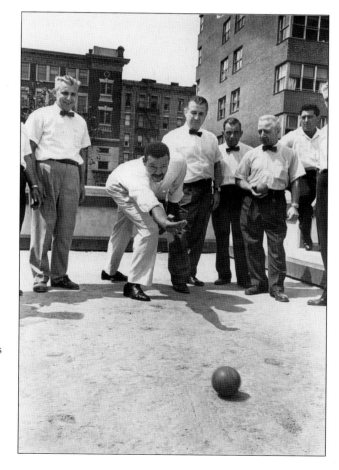

Here is a view of the inside of the bocce court at the Benjamin Franklin Plaza cooperative on 106th to 109th Streets from First to Third Avenues. Bocce, along with cards, checkers, and dominoes, were some of the games played in Italian East Harlem. Many Italian East Harlemites played bocce, but it was open to all races. Theodore "Lionel" Baker takes his turn in this early-1960s photograph. (Courtesy Theodore "Lionel" Baker.)

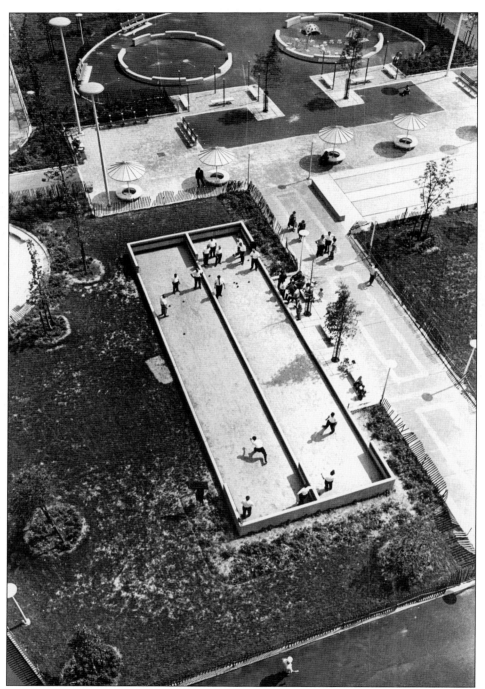

This picture, taken from an apartment in the Benjamin Franklin Plaza cooperative in the early 1960s, shows the participants playing bocce while the spectators view the game from the benches nearby. When the cooperative first opened in the early 1960s, many Italians lived here, and the management catered to the Italian community by constructing the bocce courts. (Courtesy of Theodore "Lionel" Baker.)

The Belvedere Flats and other small brownstones located on 116th Street and First Avenue was part of the neighborhood called "Doctor's Row." Doctors, lawyers, entrepreneurs, and other white-collar professionals lived in this section of Italian East Harlem during the late 1890s to 1950s. (Courtesy of the Museum of the City of New York Print Archives.)

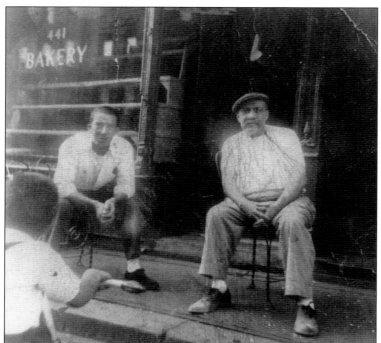

Many small stores existed in Italian East Harlem, and these businesses allowed Italian East Harlemites to commune with other Italians in the neighborhood. In this 1945 photograph, Andrea Altieri (right) sits with his son Anthony (left) in front of the bakery shop located on 441 East 117th Street. The boy on the tricycle is unidentified. (Courtesy of Angela Bella Puco.)

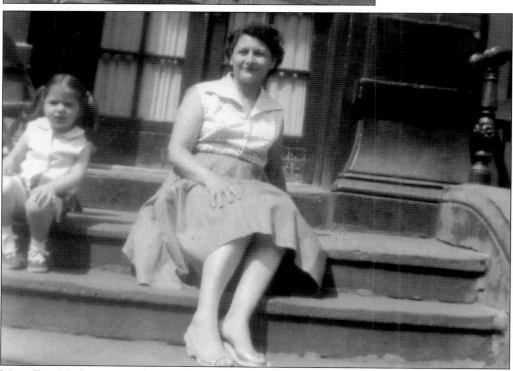

Many East Harlemites recall sitting on their stoop in front of their tenement buildings. Margaret Puco is sitting with her daughter, also named Margaret, in 1955. The building is located at 505 East 118th Street near Pleasant Avenue. (Courtesy of Angela Bell Puco.)

In 1956, young Margaret, pictured in the center, is joined by her two sisters. To her left is Cathy and on her right is Carol Ann. (Courtesy of Angela Bella Puco.)

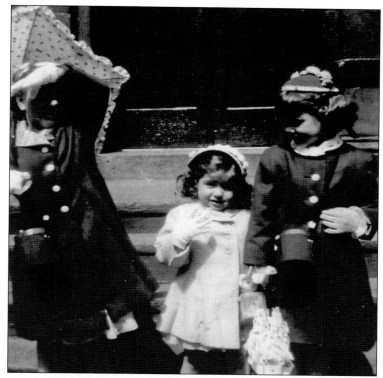

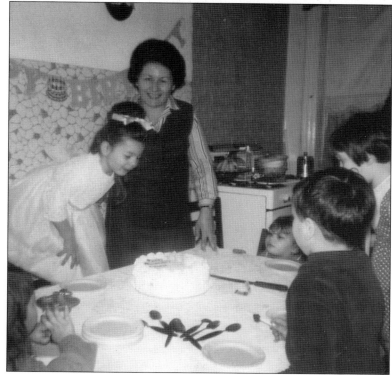

Pictured on March 30, 1966, Angela Bella Puco celebrates her fourth birthday in her East Harlem apartment. Her mother, Margaret, and her friends from the Mikros family join in the celebration. The Mikroses were one of the Greek families that lived in East Harlem. (Courtesy of Angela Bella Puco.)

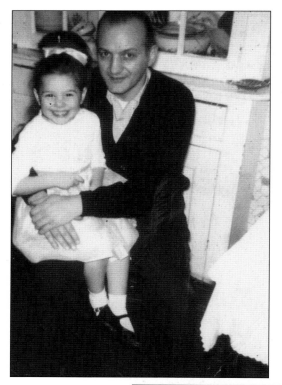

Italian East Harlemites formed a tight bond among family members, and celebrations and gatherings were commonplace. Albert Puco is seen in 1966 holding his daughter Angela on her fourth birthday. (Courtesy of Angela Bella Puco.)

Church officials are exiting first after services have just ended at Our Lady of Mount Carmel Church located on 115th Street near Pleasant Avenue. The year is 1974. (Courtesy of Edith Patenella.)

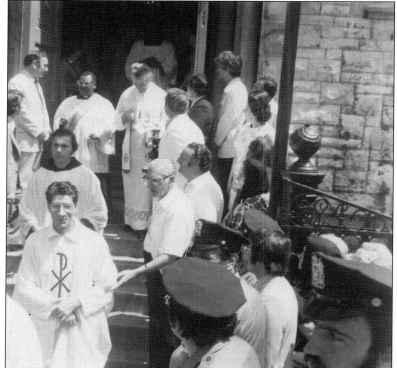

Fr. Peter Rufano, the legendary longtime priest of Our Lady of Mount Carmel, greets parishioners and well-wishers. Father Rufano, born and raised in East Harlem, was a mainstay at the church and in the neighborhood until his untimely death in 2007.

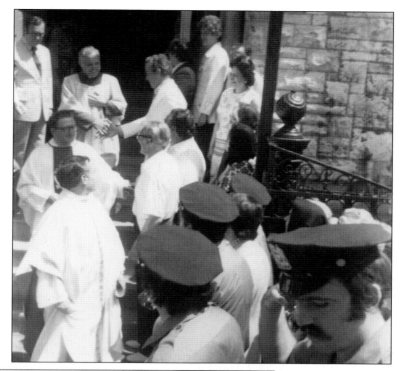

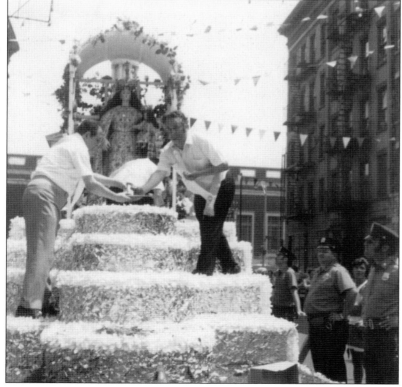

Finishing touches are applied to the float that will carry the statute of the Madonna di Constantinopolt in 1974. In the background is Benjamin Franklin High School, which was replaced by the Manhattan Center for Science and Mathematics in 1982. (Courtesy of Edith Patenella.)

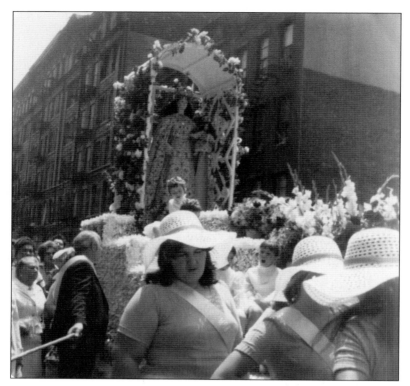

Many East Harlemites bid farewell to the float carrying the Madonna di Constantinopolt before it departs for the festival. (Courtesy of Edith Patenella.)

The Madonna makes its way through the neighborhood streets on First Avenue in 1974. Italian East Harlem shrank by the early 1970s, but many Italian East Harlemites returned to the neighborhood to attend the festivities. (Courtesy of Edith Patenella.)

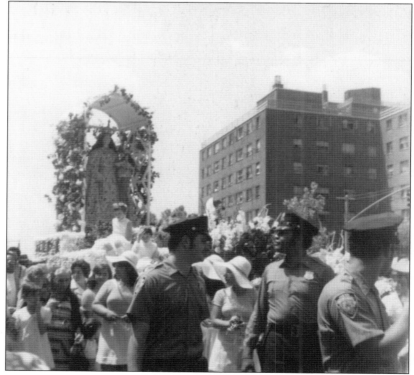

The women in the white hats, in the previous photograph and pictured here, have kept up with the float carrying the statute of the Madonna di Constantinopolt. Many residents in Italian East Harlem march step in step with the statue. Some adherents threw money at the statue to express their devotion. (Courtesy of Edith Patenella.)

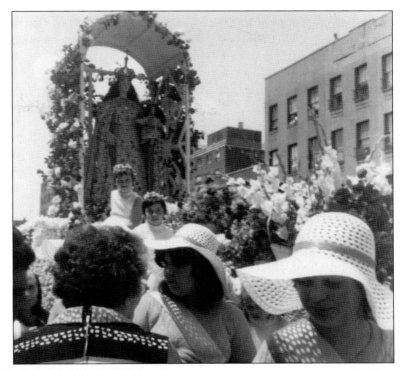

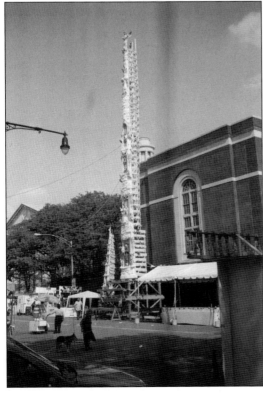

The 80-foot Giglio statue is pictured in front of the Manhattan Center for Science and Mathematics, formerly Benjamin Franklin High School.

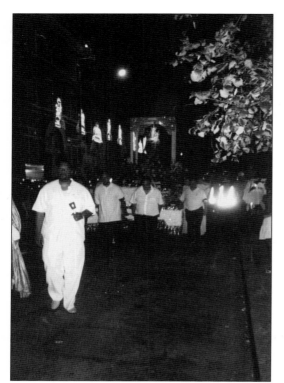

The Friday before the Mount Carmel festivities, many people march in the parade to honor the Madonna. Former Italian East Harlemites, present-day East Harlemites, and members from the Haitian community are some of the marchers in the parade.

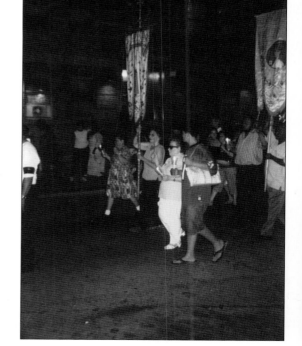

Frances Mastrota is seen in 2007 marching in the Mount Carmel Festivities with other East Harlemites. Each parade participant is given a candle to march with in the festival.

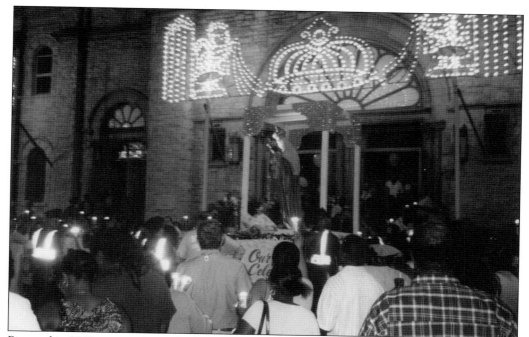

Pictured in 2007 are marchers who have gathered in front of Our Lady of Mount Carmel Church. Years ago, the festival's procession spanned many blocks throughout Italian East Harlem. The Festival of Mount Carmel waned after many Italians left the neighborhood, but it returned to East Harlem in 2000. Today the procession continues on First Avenue before returning back to the church.

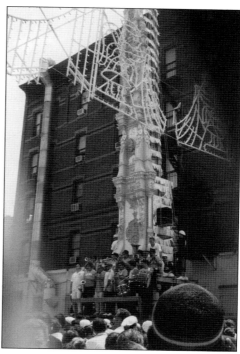

The tradition of the Dancing of the Giglio began in Italy 1,600 years ago and continued in the United States when Italian immigrants arrived in America. The average statue of the Giglio is 80 feet and weighs 8,000 pounds. An average of 100 men is needed to lift the statue. It is festooned with saints and flowers. A band is shown playing music throughout the Dancing of the Giglio.

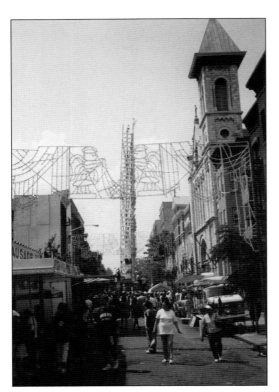

Concession stands have become part of the festival, like this one seen here on the left. The Giglio is in the center, and to the right is the Our Lady of Mount Carmel Church.

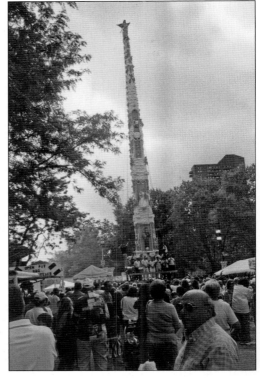

Until 2006, the Dancing of the Giglio and the Mount Carmel Festival took place on the same day, but now each event takes place separately. Here the procession of the Dancing of the Giglio begins at 114th Street and Pleasant Avenue. The year is 2007.

Members of the Giglio Society are dedicated to maintaining the Dancing of the Giglio tradition. When the festival returned to East Harlem, the Dancing of the Giglio became a part of the festivities. Pictured is the Dancing of the Giglio located on 114th Street and Pleasant Avenue in 2007.

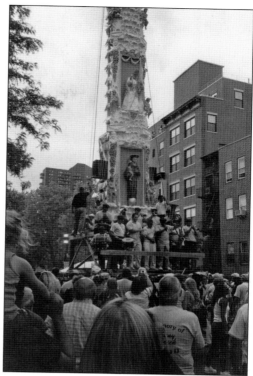

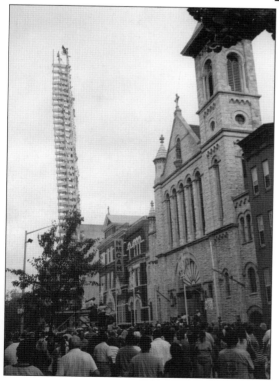

Pictured is the Dancing of the Giglio in front of Our Lady of Mount Carmel Church. Next to the church is the former National Museum of Catholic Art and History. The museum opened in 2003 but closed in 2009.

Audrey Berghaus, whose relatives hail from San Fratello, a little province in Messina, and Ann Poliseo, whose relatives hail from Bari in a province called Toritto, attend the Mount Carmel Festivities in 2007 on 115th Street and Pleasant Avenue.

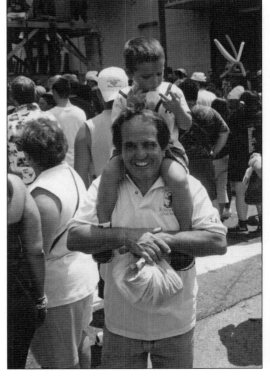

Businessman Albert Luongo poses in 2005 with his grandson at the Mount Carmel Festivities. In 2000, with the assistance of Fr. Peter Rufano of Our Lady of Mount Carmel Church, the festival returned to East Harlem. The festival, which began in Italy centuries ago, began in East Harlem in the 1880s on 110th Street and First Avenue.

Michael Lentini, head of the fathers and sons stickball league, poses in front of his stickball team's banner called the Bisons. Each September, former Italian East Harlemites return to the neighborhood on Pleasant Avenue from 116th to 117th Streets. Here these former residents and their children and grandchildren play stickball, which was a common site throughout the neighborhood.

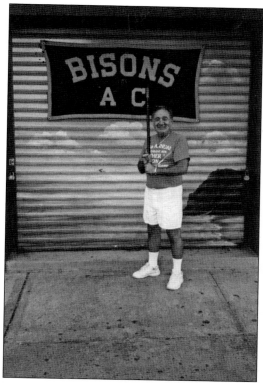

A few yards down, the street participants are seen playing stickball at the fathers and sons stickball game.

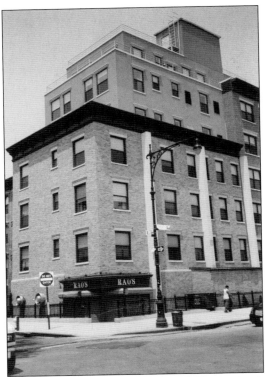

Anyone wanting a table at Rao's must be very patient. Rao's on 114th Street and Pleasant Avenue is an East Harlem institution. It opened in 1896 when Charles Rao bought the former saloon and named it Rao's. Now in its third century, the restaurant, which only has 10 tables, still is the place to be seen. And patrons will wait for almost a year to get a table at Rao's. The restaurant has hosted celebrities from actor Billy Crystal to director and actor Woody Allen. Today co-owners Frank Pelligrino Jr. and attorney Ron Straci continue the successful venture.

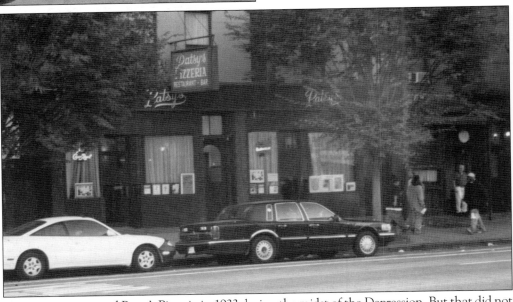

Patsy Lancieri opened Patsy's Pizzeria in 1933 during the midst of the Depression. But that did not stop East Harlemites and other New Yorkers from patronizing Patsy's. It survived the Depression and is still going strong 77 years later; it has become one of East Harlem's mainstays. Patsy's thin crust pizza is a hallmark of the restaurant's specialty and entices patrons to return time and time again. Today owners Frank Brija and John Brecovich continue the tradition of providing customers with great food.

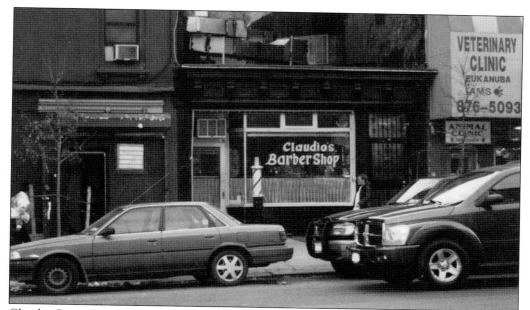

Claudio Caponigro opened the barbershop that bears his name in 1950 on 116th Street near First Avenue. Back then the neighborhood was heavily Italian. Though Italian East Harlem has long faded, Claudio has not, and 60 years later Claudio's is still open for business. As with the other establishments in Italian East Harlem, former residents return and new customers arrive to just have their locks clipped or trimmed by Claudio.

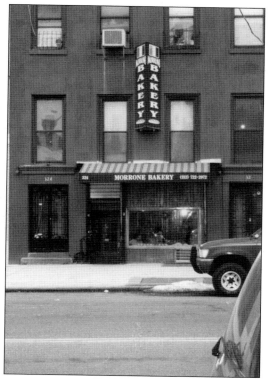

This is a 2004 photograph of Marrone Bakery, which was founded by Rosa and Gabriele Marrone in June 1956. For over 50 years, many East Harlemites flocked to the bakery located on 116th Street between First and Second Avenues. Here East Harlemites were treated to fresh bread, cookies, and other treats. After Italian East Harlem faded and was replaced by Puerto Ricans, Mexicans, and other Latinos, patrons and former residents routinely returned to Marrone Bakery to shop. Unfortunately, the bakery closed in 2007.

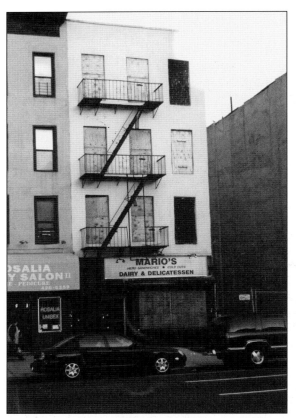

Seen here is Mario's Dairy and Delicatessen, located on the first floor on 115th–116th Streets and Second Avenue. It was known for its inexpensive hero sandwiches smothered in provolone cheese. Today East Harlemites miss Mario's after a fire felled it in 2005.

This photograph of Delightful Restaurant is a sight for sore eyes among many East Harlemites. For 83 years, the restaurant, once located on 116th Street and First Avenue, was a favorite for its old-fashioned hospitality. More than just a restaurant, Delightful was an information center where East Harlemites heard the latest news and gossip. Celebrities, from actors Anthony Quinn, Al Pacino, and Ice-T, to singer and actress Jennifer Lopez, and football great Lawrence Taylor were just some of the famous people that ate at Delightful. It closed in September 2005.

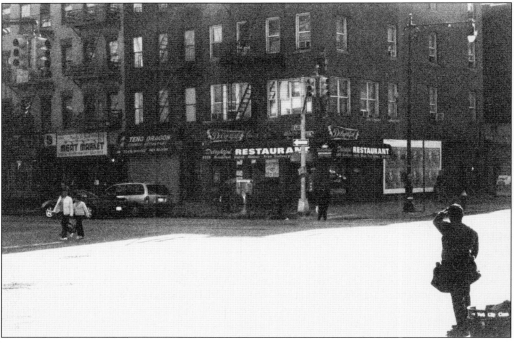

Five

FAMOUS PEOPLE AND PLACES

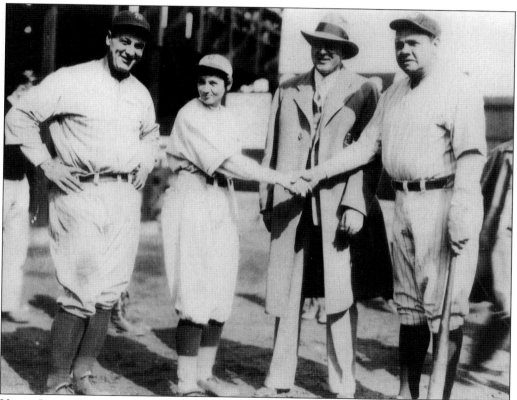

Henry Louis "Lou" Gehrig was a baseball player nicknamed the "Iron Horse" for his durable athletic career. Gehrig held the mark for 2,130 consecutive games played until Baltimore Orioles shortstop Cal Ripkin set a new record in September 1995. He was born on 102nd and 103rd Streets and Second Avenue. There was more to Gehrig than the games streak. Gehrig won two most valuable players awards in 1927 (Chalmers award) and in 1934. That year he also won the triple-crown. Gehrig appeared in seven World Series and was triumphant in six of them. Tragically, Gehrig's career and life was cut short by the disease that bears his name, Lou Gehrig's Disease or Amyotrophic Lateral Sclerosis. Gehrig is shown in 1931 with his teammate Babe Ruth and Joe Engel. The woman in the photograph is unidentified. (Courtesy of the Library of Congress.)

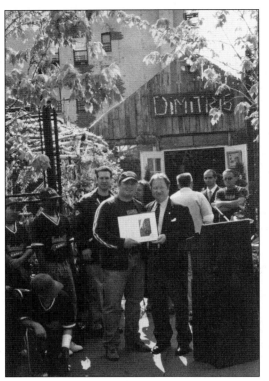

Dimitri Gatanas is pictured in 2005 with a photograph of Lou Gehrig's birthplace. The tenement building where Gehrig was born was demolished, and years later, Dimitri opened a flower shop at the same location where Gehrig once lived. Officials from the New York Yankees and New Yorkers living with ALS also attended the festivities.

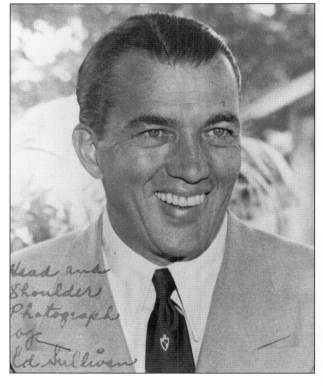

Ed Sullivan spent his early childhood in East Harlem on 114th Street. This former pugilist, sports reporter, and Broadway columnist first tasted success on WABC radio, which became WCBS radio. However, his lasting legacy was on television. Longtime fans recall that the variety show that Sullivan first hosted was called the *Toast of the Town*. Later it was renamed the *Ed Sullivan Show*, which ran from 1948 to 1971. (Courtesy of the Library of Congress.)

Internationally acclaimed opera singer Reri Grist lived on 102nd Street and First Avenue. Audiences first heard the song "Somewhere" when Grist performed it in the original production of Leonard Bernstein's *West Side Story* in 1957. She continued to give performances throughout the United States and Europe until she retired in 1991. She is pictured in the 1960s. (Courtesy of Ray Grist.)

Eddie Palmieri, a versatile performer, was born in East Harlem on 112th Street. Eddie is the younger brother of musician Charlie Palmieri, who was also an accomplished pianist in his own right. Palmieri studied piano in his youth, and one of his earliest appearances occurred in Carnegie Hall at age 11. A professional performer since the early 1950s, this five-time Grammy winner has played with many Latin Giants, including Tito Rodriguez, Tito Puente, and Machito. He was also honored by the legislatures of both New York State and in Puerto Rico. He is shown in 2006 at El Museo Del Barrio with activist Dylcia Pagan and artist Yazmin Hernandez. The gentleman next to Hernandez is unidentified.

Born Marco Antonio Muniz after a famous Mexican singer, singer and actor Marc Anthony lived in East Harlem on 101st Street. One of his many hits includes "I Need to Know." In addition to his singing career, Marc is an accomplished stage and screen actor. His movie credits include *Man on Fire* with costar Denzel Washington and *El Cantante* ("The Singer"), a movie biography of the late salsa singer Hector Lavoe. In 2010, Marc Anthony was bestowed the honor as the King of the 53rd Annual Puerto Rican Day Parade. Marc is shown here performing at NBC's *Today Show's* summer concert series.

Tito Rodriguez was a singer who was known to fans as "El Inolvidable" ("The Unforgettable"). Rodriguez arrived in East Harlem from Puerto Rico at 17 and lived on East 110th Street between Fifth and Madison Avenues. After his arrival, Rodriguez secured work with Xavier Cugat. He also studied at the Julliard School for Music and later formed his own band, which became the Tito Rodriguez Orchestra. His successful recordings include "En La Soledad" ("In Solitude"). He is pictured in the 1950s. (Courtesy of Angel Rene.)

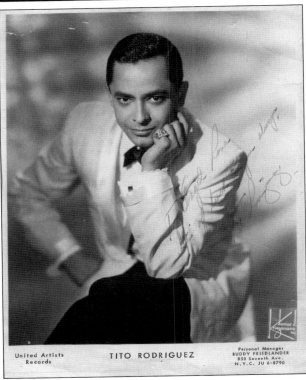

United Artists Records

TITO RODRIGUEZ

Personal Manager
BUDDY FRIEDLANDER
850 Seventh Ave.
N.Y.C. JU 6-8790

Writer Arthur Miller, one of America's greatest playwrights, also lived in East Harlem on East 110th Street. Miller first began publishing plays in the late 1930s. He is best remembered for *All My Sons*, which won the New York Drama Critics Award. Other works included *Death of a Salesman*, winner of the 1949 Pulitzer Prize; *The Crucible*; and *A View from the Bridge*. Miller is seen at his typewriter in this 1940s photograph. (Courtesy of the Library of Congress.)

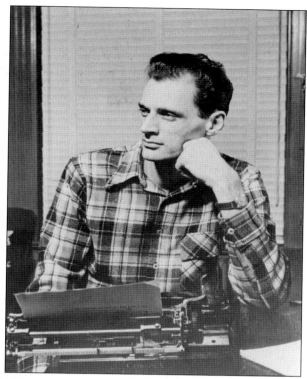

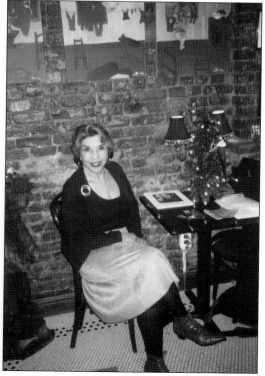

Prolific writer Nicholasa Mohr has authored over 30 books. She spent her early years in East Harlem on 100th, 105th, and 108th Streets. Her first book, *Nilda*, won the New York Times Book Award. Other notable works include *El Bronx Remembered* and *Felita*. Nicholasa is seen here at Jake's, a popular bar on East 103rd Street, in 2005.

Philanthropist Eugene Lang was raised in East Harlem and attended Public School 121, located on 102nd Street between Second and Third Avenues. In 1981, Lang was invited back to the same school where he had graduated 50 years earlier. Lang was about to speak to the sixth grade commencement class without any preparation, and then suddenly he thought of Dr. Martin Luther Kings Jr.'s "I Have a Dream Speech." Seconds later, Lang spontaneously promised to provide college scholarships to the graduating class. Five years later, he took his vision around the country. Today numerous sponsors have provided college scholarships to thousands of children throughout America. Here Lang poses with the original "I Have a Dream Class" in the 1980s at 104th Street between Park and Lexington Avenues. (Courtesy of Eugene Lang.)

Dr. Jonas Salk, who in 1955 discovered the vaccine to successfully combat polio, lived in East Harlem before his family moved to the Bronx and Queens. He returned to the Harlem area where he attended City College. Dr. Salk is seen here inoculating a young child with the vaccine in the 1950s. Two nurses help Dr. Salk with the task. (Courtesy of the Library of Congress.)

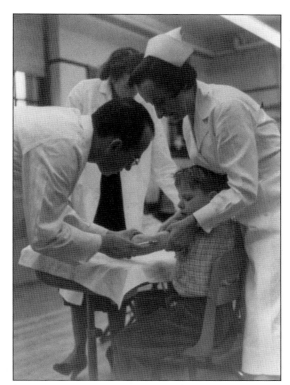

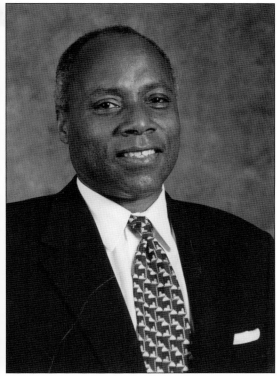

Politician William "Bill" Perkins served in the New York City Council representing both East and West Harlem. Today Perkins still represents both communities in the New York State Senate. He is pictured in the late 1990s. (Courtesy of William Perkins.)

Sen. Jose M. Serrano was elected to the New York State Senate in November 2004. He represents the 28th Senate District, which includes neighborhoods in the South and West Bronx, East Harlem, Yorkville, and Roosevelt Island. He is secretary of the Majority Conference and currently serves as chair of Cultural Affairs, Tourism, Parks, and Recreation. Senator Serrano holds a deep appreciation for the arts and has dedicated himself to using it as a vehicle for community empowerment and economic revitalization.

Actor Malik Yoba has appeared in numerous television and film roles, most notably *New York Undercover* and *Cool Runnings*. Yoba was raised at 1199 Plaza on 108th-109th Streets and First Avenue. Malik is shown here with his mother, Mahmudah Young. (Courtesy of Mahmudah Young.)

Musician Johnny Colon first lived in East Harlem on 106th Street between Park and Madison Avenues. Colon has taught and performed music for over 50 years. Many of today's Latin musicians were trained by Colon through the Johnny Colon Music School that was once on 104th Street near Third Avenue. His 1962 hit "Boogaloo Blues" is still a fan favorite among many East Harlemites. He is pictured in 2004 with Leslie Whyche at Jake's fine wines and beer.

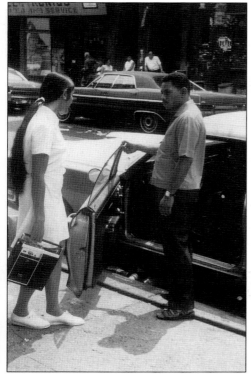

Joe Bataan, whose real name is Bataan Nitollano, was raised on 103rd Street and Lexington Avenue. Bataan merged the Latin boogaloo and African American doo-wop into the 1967 hit song "Gypsy Woman." His daughter Aisa Nitollano is a former member of the Pussycat Dolls. Bataan is seen in the 1960s with his wife, Sylvia, holding a radio, on 104th Street between Lexington and Third Avenues. (Courtesy of Manny Segarra.)

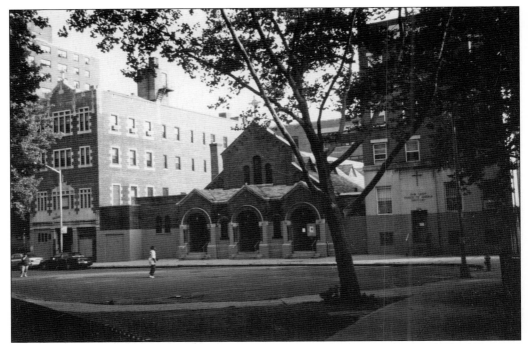

Our Lady Queen of Angels was once located on 113th Street between Second and Third Avenues. The church was built in the 1870s. When it first opened, many of its congregants were German and Irish immigrants. Over the years, Italians, Puerto Ricans, Mexicans, and other Latinos worshipped at the church. The church closed in 2007 due to a declining number of parishioners.

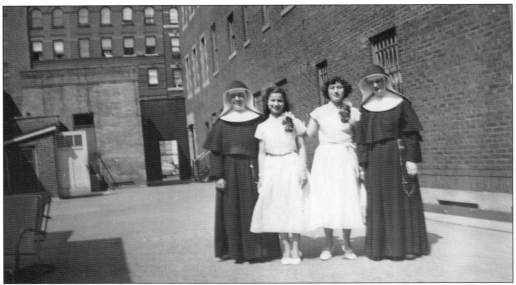

Pictured from left to right are Sister Mary Timothy, Helen ?, Evelyn ?, and Sister Jacqueline next to a side entrance to Our Lady Queen of Angels in 1950. (Courtesy of Edith Patenella.)

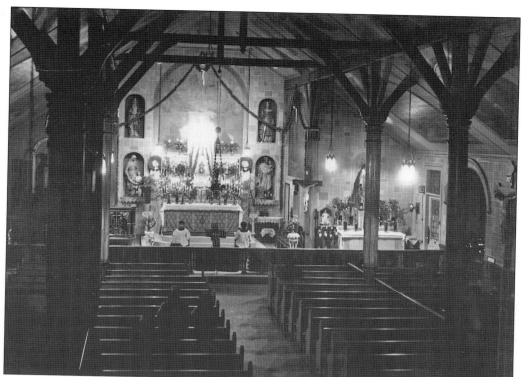

Two altar boys are at work inside of Our Lady Queen of Angels during the 1940s. (Courtesy of Our Lady Queen of Angels.)

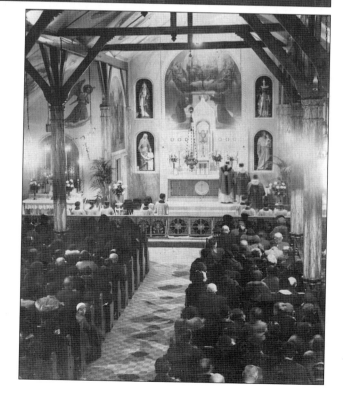

A church service at Our Lady Queen of Angels is pictured in the 1940s. As seen here, the church was heavily attended by East Harlemites. One could hardly imagine that one day the church would close. (Courtesy of Our Lady Queen of Angels.)

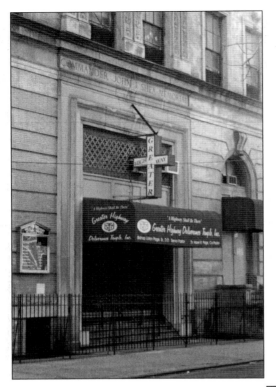

The Greater Highway Deliverance Temple Church, Inc., formerly Commander John J. Shea Memorial, which closed in 1971, is located on 111th Street between Park and Lexington Avenues. The current senior pastor is Liston Page Sr.

Saint Paul's Church is located on 117th Street between Park and Lexington Avenues. The church was founded in 1834 as one of the original six churches built in New York City. The parish school was added in 1872.

The Islamic Cultural Center is located at 1711 Third Avenue between Ninety-sixth and Ninety-seventh Streets. The mosques' construction began on the last day of Ramadan on May 28, 1987. After several delays, the mosque opened on April 15, 1991, the feast of Eid-ul Fitr. Reminiscent of all mosques, the Islamic Cultural Center is directed towards Mecca.

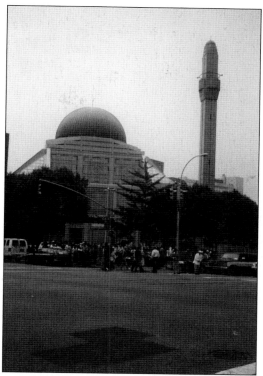

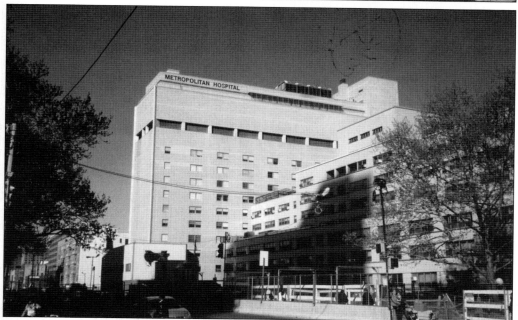

Metropolitan Hospital is located at 1901 First Avenue between Ninety-seventh and Ninety-nine Streets. The former Homeopathic Hospital began in 1875 on Ward's Island; it was renamed Metropolitan Hospital when it relocated to Roosevelt Island in 1884. The hospital moved one final time in 1955 to its present location.

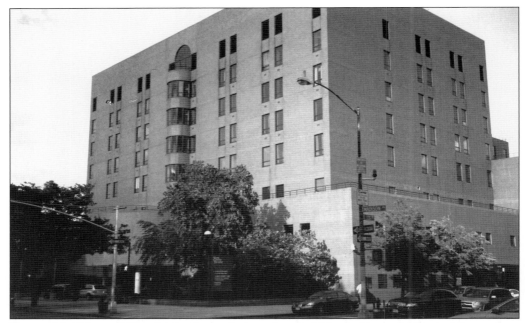

Eugene McCabe and Randolph Guggenheimer founded North General Hospital, located on 120th-121st Streets and Madison Avenue, in 1979. The hospital proudly serves the people of both East and Central Harlem. It was designated a stroke center by New York State and provides residency training services in internal medicine, psychiatry, and podiatry. Unfortunately, the hospital closed in 2010.

The Terence Cardinal Cooke Center is located on Fifth Avenue between 105th and 106th Streets. The center originally began as the Flower Fifth (Avenue) Hospital, which opened in 1890 as a neighborhood hospital. Flower Fifth Avenue Hospital closed and reopened under the direction of the archdiocese. In 1984, the center was named after Terence Cardinal Cooke, who died the previous year. Today the hospital provides care for the elderly, disabled youth, AIDS patients, and people who live with Alzheimer's disease.

Six

CHANGING SCENES

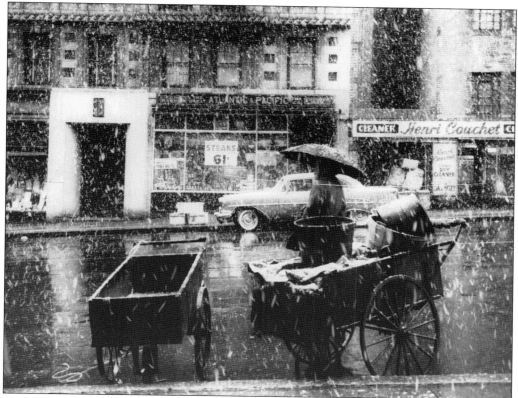

The temperature is hovering around the freezing point at 32 degrees in this 1956 view. Though snow has not accumulated on the ground, this East Harlemite needs an umbrella to battle the elements. The location is on Madison Avenue between Ninety-sixth and Ninety-seventh Streets. (Photograph by John Albok; reprinted with the permission of Ilona Albok Vitarius.)

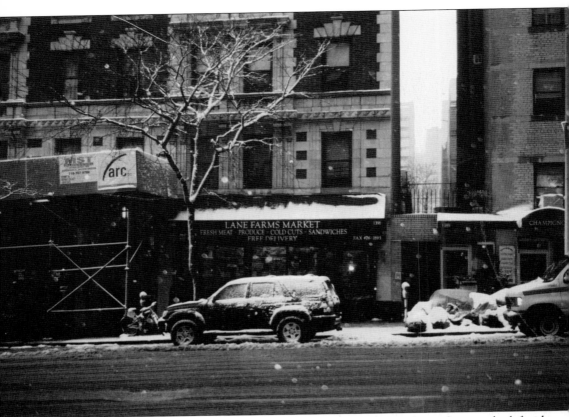

Fifty years later, the block has not changed. Though construction is taking place on the left side of the photograph, the neighborhood block is still intact. However, this time snow has blanketed the street.

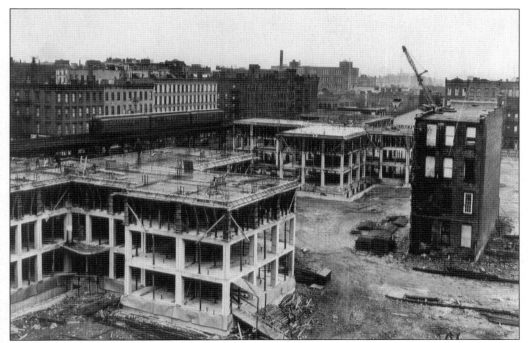

The construction of the James Weldon Johnson Houses at 112th–115th Streets between Lexington and Third Avenues is pictured in this 1946 photograph. The Third Avenue El can be seen in the distance. (Courtesy of the Library of Congress.)

Pictured here are the James Weldon Johnson Houses that were completed and fully tenanted by 1948. Some 1,310 units are part of the Johnson Houses.

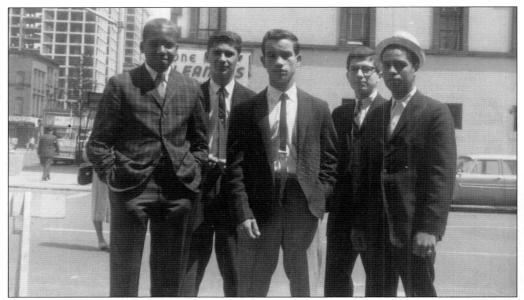

These East Harlemites pose for a photograph on 106th Street and Lexington Avenue in 1964. In the far left corner is the Boricua Theatre (formerly the Fox Star), which closed in the early 1960s and was used by several community-based organizations. The theater was up for sale when this picture was taken. Rising above the neighborhood is the construction of the DeWitt Clinton Houses. (Courtesy of Manny Segarra.)

The tenement building on 106th Street still stands, and in the far left is the DeWitt Clinton House, which was completed and fully tenanted in 1965. The Boricua Theatre (Fox Star) was demolished, and for many years the block became a vacant lot used by musicians and street carnivals. In the early 1980s, the Lexington Gardens, a housing development, was built on the same site that once served moviegoers.

East River Houses is located at 102nd–105th Streets and Fifth Avenue to the East River. Before the housing project was built, the East Harlem Business Mart operated at this location. Ground was broken on East Harlem's first housing project on March 2, 1940, and 14 months later, the housing complex opened. The East River Houses have 1,166 apartments. Many buildings in this complex are six stories, which at that time was consistent with the neighborhood's five- and six-story tenements.

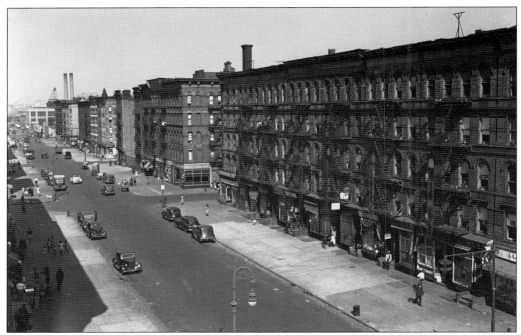

This photograph was taken on the corner of 132nd Street and Fifth Avenue in 1944. Pictured here are the neighborhood's tenements and small stores. (Courtesy of the New York City Public Housing Authority.)

Two years later the tenements were torn down and replaced by the Abraham Lincoln Houses, which covers 132nd through 135th Streets from Fifth to Park Avenues. The housing complex opened in December 1947 and is home to 1,286 units. Fifth Avenue divides East and West Harlem. The Abraham Lincoln Houses are on the east side of Fifth Avenue.

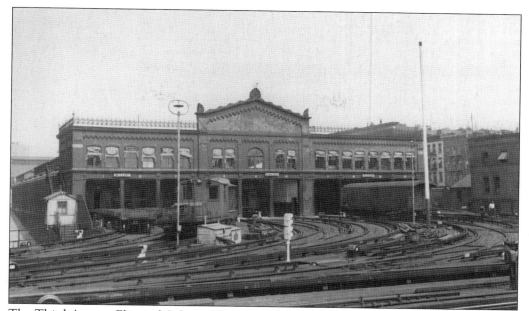

The Third Avenue Elevated Subway Ninety-ninth Street garage was located between Ninety-eighth and Ninety-ninth Streets and Third Avenue. Many elevated subways would detour into the garage for maintenance, repairs, or to store the subway cars during nonpeak hours. It is shown here in 1937. (Courtesy of Steven L. Meyers; photograph by Al Siegel.)

The Third Avenue Elevated garage was demolished in 1949 and replaced by the Lexington Houses located on the same site on Ninety-eighth and Ninety-ninth Streets and Third Avenue. This complex was built in 1950 and is home to 448 families. The only thing remaining from the previous photograph is the office building on the right.

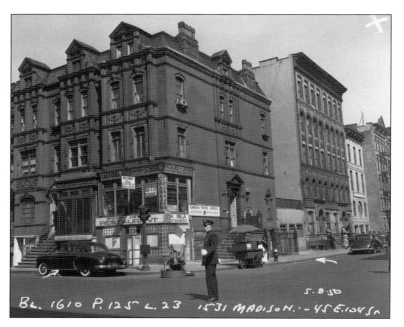

A traffic policeman is seen in this 1950 photograph on the corner of 104th Street and Madison Avenue. Elegant brownstones and tenements were once located on Fifth and Madison Avenues. (Courtesy of the New York City Public Housing Authority.)

The brownstones and tenements were demolished and replaced by the George Washington Carver Houses, which were fully tenanted in 1958. This complex holds 1,246 units and is located from Ninety-ninth to 106th Streets between Madison and Park Avenues.

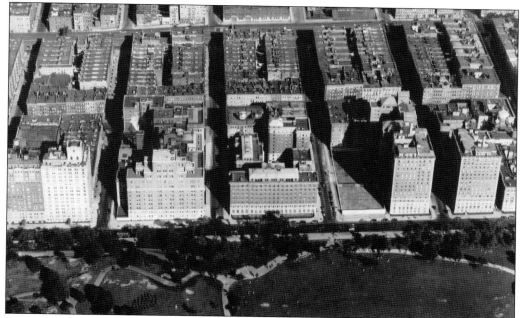

This 1946 aerial view looks at an expanded photograph of Mount Sinai Hospital, located at Ninety-ninth through 102nd Streets between Fifth and Madison Avenues. Directly behind the hospital are some of the many tenements that made up the East Harlem neighborhood. (Courtesy of Mount Sinai Hospital.)

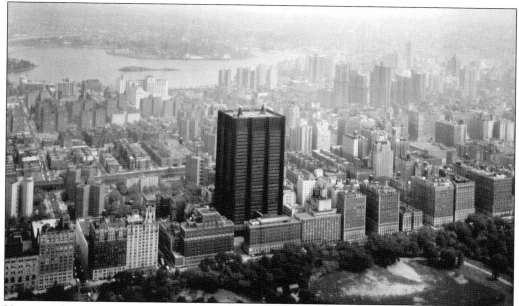

Here is a photograph of the same location taken nearly 30 years later in 1974. The buildings on Fifth Avenue still remain, but the structures in the center on 100th Street were demolished and replaced by this large edifice in 1963. The tenements in the original photograph were demolished between 1952 and 1953 and replaced by the George Washington Carver Houses. (Courtesy of Mount Sinai Hospital.)

This photograph was taken from an apartment in the James Weldon Johnson Houses in 1952. Prior to the construction of the Thomas Jefferson Houses at 112th through 115th Streets between First and Third Avenues, many 19th-century old law tenements existed at this location. The cross streets on 113th and 114th were in use. The Third Avenue El can be seen in the middle of the block. (Courtesy of Catherine Brockington.)

The tenements were demolished in the mid-1950s and replaced by the Thomas Jefferson Houses, which were fully tenanted in 1959. All small stores and cross streets were eliminated and replaced by the super block. The super block combines two or three blocks together to form one giant block, which is suitable to build public housing. The green expanse and trees are a permanent feature of all public housing projects. The Jefferson Houses contains 1,493 units.

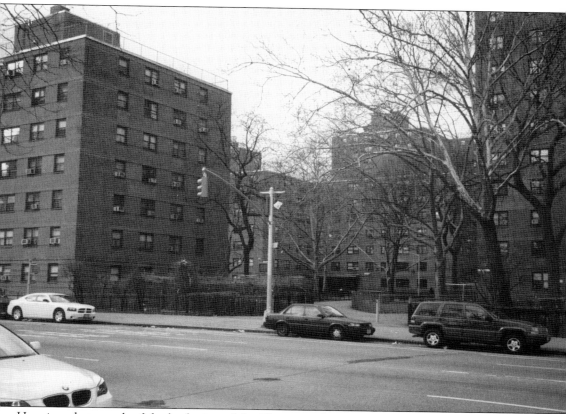

Here is a photograph of the back view of the Thomas Jefferson Houses on the same location of the erstwhile tenements. Similar to East River Houses, many seven-story housing projects were constructed to maintain the character of the former neighborhood.

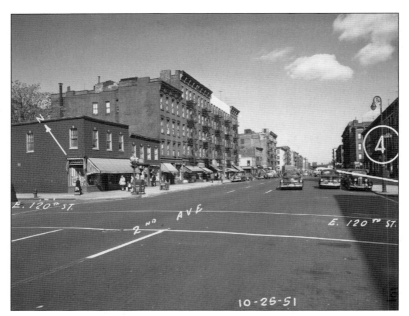

This 1951 photograph of 120th Street and Second Avenue profiles another part of Italian East Harlem. (Courtesy of the New York City Public Housing Authority.)

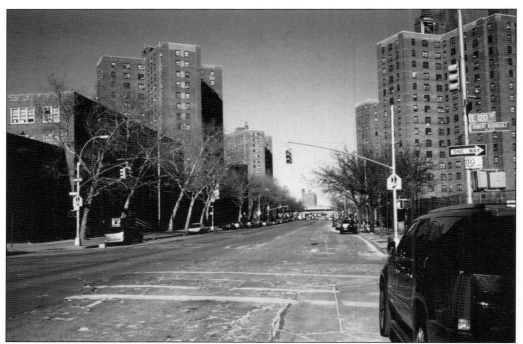

Like before, the buildings and stores were gone by 1955 and replaced by the Sen. Robert F. Wagner Sr. Houses. Originally the housing project was to be called the Triborough Houses. Instead, the project was renamed in honor of the former New York U.S. senator who helped pass the Wagner Act. This act helped create the New York City Housing Authority. Some 2,162 housing units are part of this complex.

Seen in 1953 is Frawley Circle on the west side of Park Avenue between 114th and 115th Streets. In addition to the tenements, on the corner is Siegel's Drugstore. (Courtesy of the New York City Public Housing Authority.)

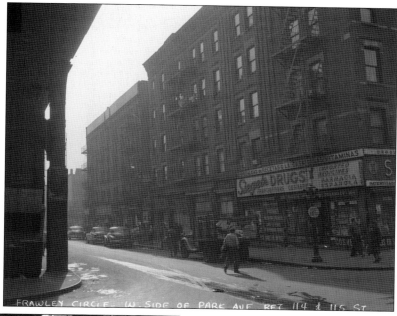

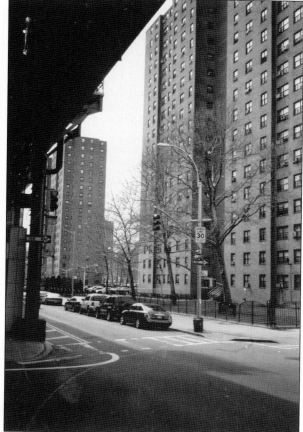

Frawley Circle is pictured today. In 1958, Siegel's Drugstore and the tenements became a memory, and the Robert A. Taft Houses rose in its place. The complex is located from 112th to 115th Streets between Fifth and Park Avenues and holds 1,440 units. It was named in honor of the late Ohio senator and son of former president and Supreme Court justice William Howard Taft.

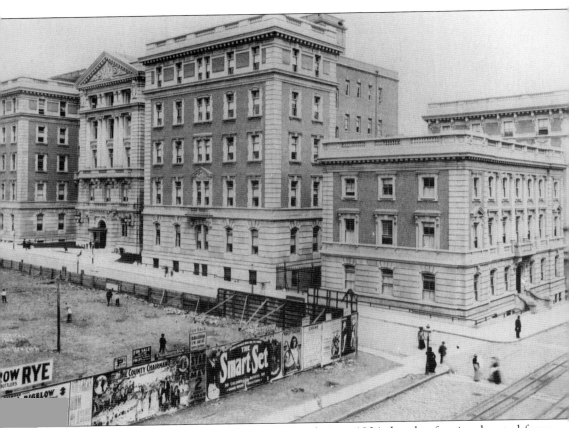

This photograph of Mount Sinai Hospital was taken in 1904 shortly after it relocated from downtown Manhattan. Originally the Jews Hospital in downtown Manhattan in 1852, it was renamed Mount Sinai hospital 14 years later. The hospital moved again to midtown Manhattan in 1872 before it finally established its first East Harlem residence when it relocated to 100th Street and Fifth Avenue. For over a century, Mount Sinai Hospital has been a proud partner in the East Harlem community. The hospital has provided quality health care and has been a leader in developing the next generations of doctors. (Courtesy of Mount Sinai Hospital.)

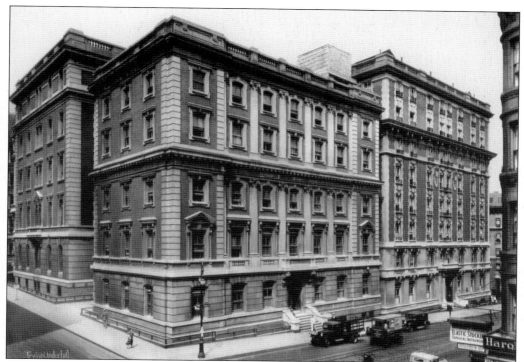

Mount Sinai Hospital is pictured 30 years later in the 1930s at 100th Street and Madison Avenue. The hospital expanded by constructing two additional floors. During this period, neighborhood mom-and-pop stores were adjacent to the nearby tenements. (Courtesy of Mount Sinai Hospital.)

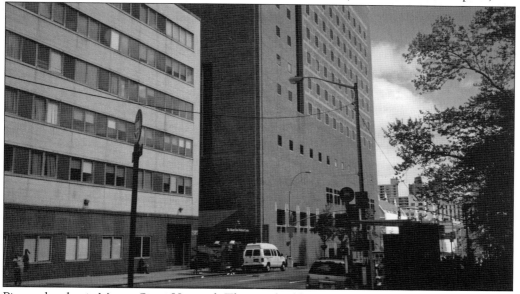

Pictured today is Mount Sinai Hospital. The two buildings on the right were demolished and replaced by a beautifully designed edifice, which encompasses Ninety-ninth to 100th Streets and Madison Avenue. Patients and visitors marvel at the spacious electronic revolving door that allows the public to enter without feeling confined.

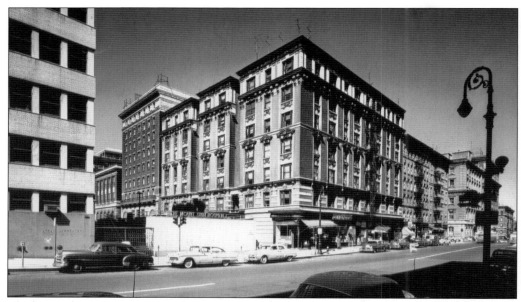

The hospital refused to compromise and continued to flourish. The yard in the earlier photograph was replaced when Mount Sinai Hospital opened a few buildings located several blocks north on Ninety-eighth to Ninety-ninth Streets and Madison Avenue. In 1958, when the picture was taken, two-way traffic still existed on Madison Avenue. (Courtesy of Mount Sinai Hospital.)

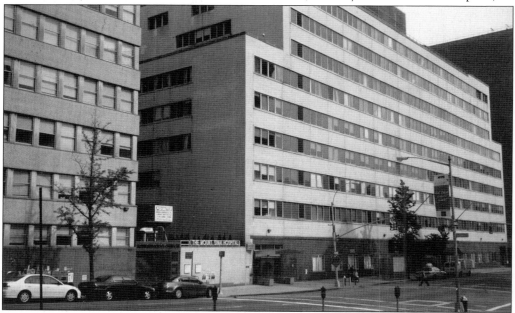

Mount Sinai Hospital is pictured today. The building on the left has remained the same, however, the buildings on the right were demolished and replaced. Traffic is now one way and heads north. In addition, the hospital opened the Mount Sinai Medical School in 1968, then affiliated with the City College of New York. Since then, it has developed a partnership with New York University. Today the hospital has over 1,100 beds with 2,200 physicians on hand to provide service to anyone who needs medical attention.

This is a present-day photograph of the Boys and Girls Club, which was renamed the Elbridge T. Gerry Clubhouse. Many know Elbridge Gerry as the former Massachusetts governor for whom the term "Gerrymandering" was named. The Gerry family has become involved with the Boy's and Girl's Club, and in East Harlem, the Gerry Clubhouse is one of the biggest clubhouses in America. To date, 1,700 members are part of the Boy's and Girl's Club. In addition, 300 children walk through its doors everyday, making it one of the busiest Boy's and Girl's Clubs in the city.

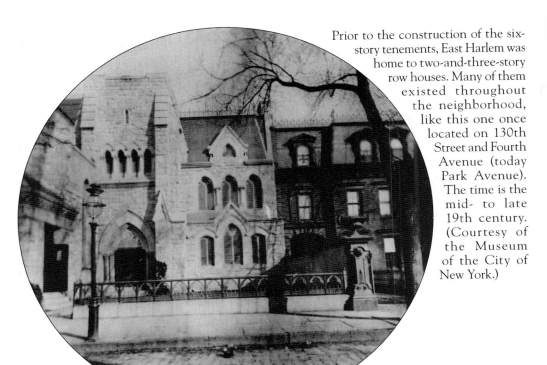

Prior to the construction of the six-story tenements, East Harlem was home to two-and-three-story row houses. Many of them existed throughout the neighborhood, like this one once located on 130th Street and Fourth Avenue (today Park Avenue). The time is the mid- to late 19th century. (Courtesy of the Museum of the City of New York.)

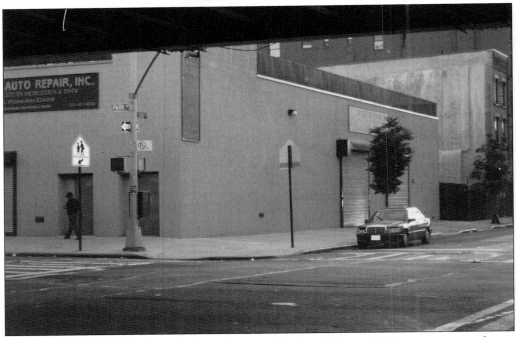

Seen here is 130th Street and Park Avenue (formerly Fourth Avenue). The two-story row house was demolished. Today this auto repair business and tenement building are part of the block.

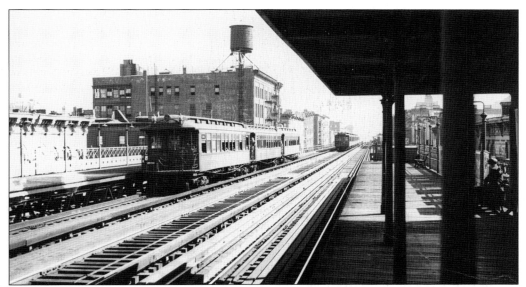

The Third Avenue Elevated Subway is approaching the Ninety-ninth Street Station and Third Avenue in this 1940 photograph. An express subway can be seen in the distance. (Courtesy of the collection of Steven L. Meyers; photograph by Al Siebel.)

Pictured are Third Avenue and Ninety-ninth Street. The Third Avenue Elevated Subway was demolished in 1955, which allowed for the construction of many tall buildings along Third Avenue.

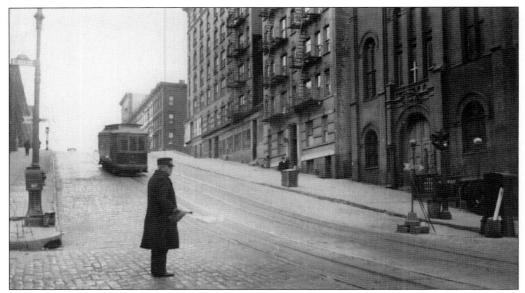

Seen in 1935 is 103rd Street at Lexington Avenue as the trolley car is traveling down the hill. The traffic policeman is in front with a white flag to signal if it is safe for East Harlemites to cross the street. A chair under the lamppost allows the gentleman to sit when the traffic is idle. On the right is the St. Georges Greek Church, which later became the St. George and St. Demetrious Church. (Courtesy of the collection of Steven L. Meyers; photograph by Al Siebel.)

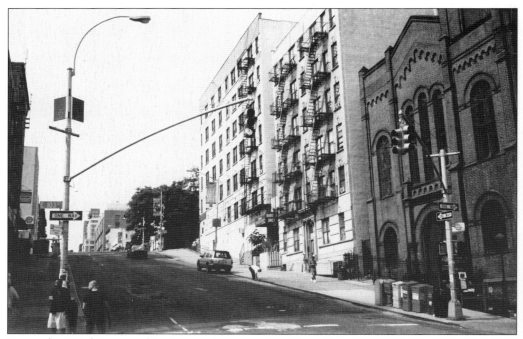

Pictured is 103rd Street and Lexington Avenue today. The trolley cars ceased running in New York City, and the cobblestone streets were paved over. Many buildings in the previous photographs still exist today.

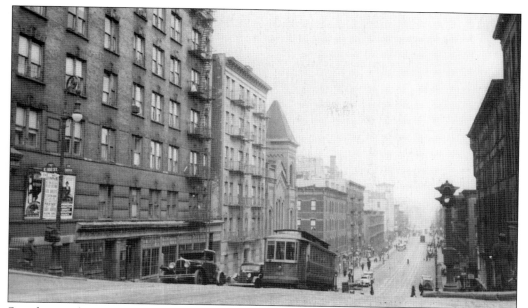

Seen here is the view from the top of the hill at 102nd Street and Lexington Avenue in 1935. The trolley cars and vintage automobiles are ascending the hill, which then allowed two-way traffic. To the left of the building are movie advertisements, and on the right is the old-style traffic light that then displayed two colors: red and green.

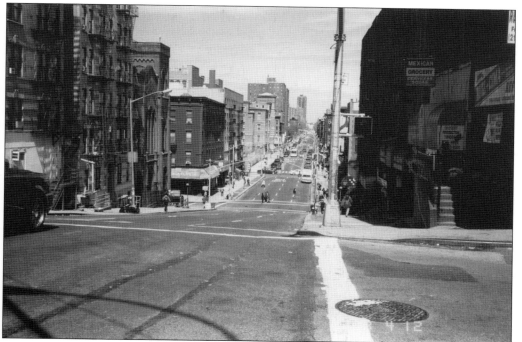

Here is a 2003 photograph of 102nd Street and Lexington Avenue. Today the traffic along Lexington Avenue moves one way, and the electric crosswalk sign has replaced the red and green traffic light.

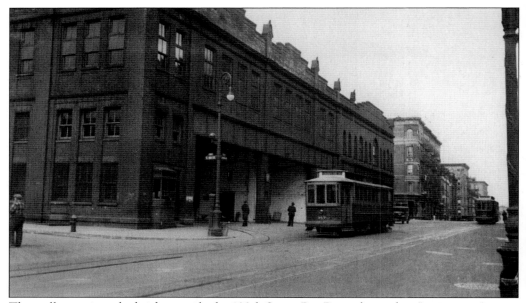

The trolley car is parked right outside the 100th Street Bus Depot located on Lexington Avenue between Ninety-ninth and 100th Streets in 1935. (Courtesy of the collection of Steven L. Meyers; photograph by Al Siebel.)

Pictured today is the 100th Street Bus Depot. The original 100th Street Bus Depot was demolished and rebuilt in 2000. The bus has replaced the trolley cars at this location.

Seven

STREET SCENES

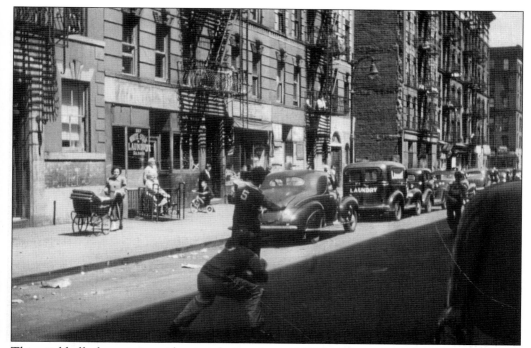

This stickball player is in mid-swing during the mid-1950s. Moments earlier, the pitcher just released the ball. The location is 100th Street between First and Second Avenues. (Courtesy of the Reverend Norman C. Eddy.)

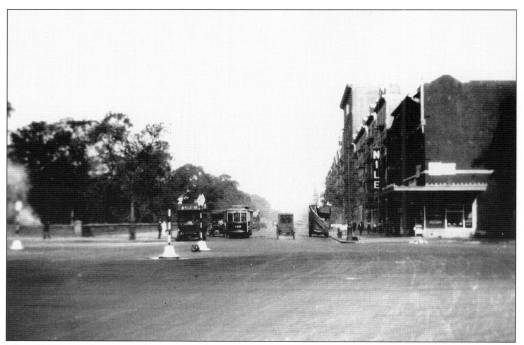

This 1917 view shows 110th Street and Fifth Avenue looking west. The vehicle on the left is from the Fifth Avenue Coach Company. (Courtesy of the collection of Steven L. Myers.)

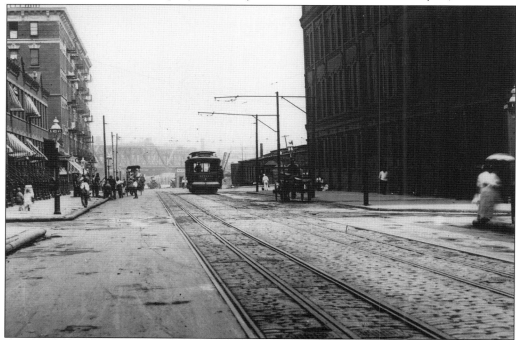

This rare, early-20th-century photograph shows the New York Railway's open car on a shared track behind the Third Avenue Railways. The Third Avenue barn is on the right. The location is 129th Street and Third Avenue. (Courtesy of Steven L. Meyers and Vincent Seyfried.)

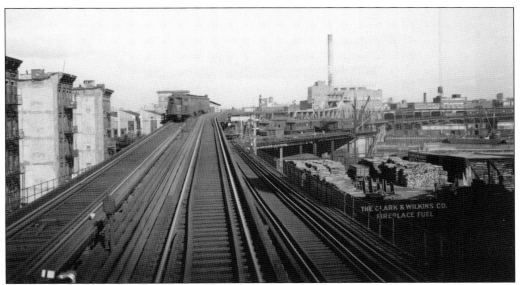

This 1940 photograph was taken from the express lane of the Second Avenue El, passing the 125th Street Station. A southbound elevated subway is leaving the 129th Street Station. (Courtesy of the collection of Steven L. Meyers; photograph by Al Seibel.)

East Harlemites are seen standing in front of a New York City transit bus in 1963. In the early 1960s, the fare to ride both the city's subways and buses was 15¢. The bus driver dispensed change to the customers until 1966. The location is 129th Street and Madison Avenue. (Courtesy of Vickie Beckford.)

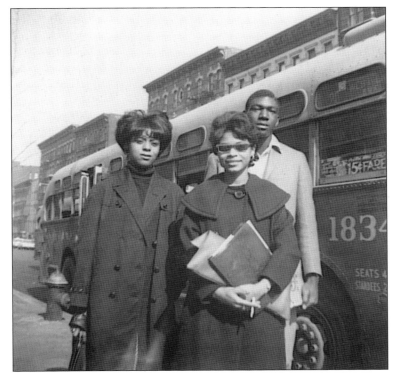

This young teenager poses in front of a city bus sign directly across the street from the previous photograph in 1963. The location is 129th-130th Streets and Madison Avenue. (Courtesy of Vickie Beckford.)

One block north on 130th-131st Streets, a mother and child pose for pictures in 1965. The Abraham Lincoln Houses can be seen in the distance. In this photograph, a sharp difference is seen between the five-story tenement with its small, ground-floor stores and the high-rise housing projects built without any small store or business space. (Courtesy of Vickie Beckford.)

Four adolescents are pictured at the local candy store. The location is directly across the street from the previous photograph at 131st-132nd Streets and Madison Avenue. As Jane Jacobs once said, "Small stores brought life and businesses on each neighborhood block." (Courtesy of Vickie Beckford.)

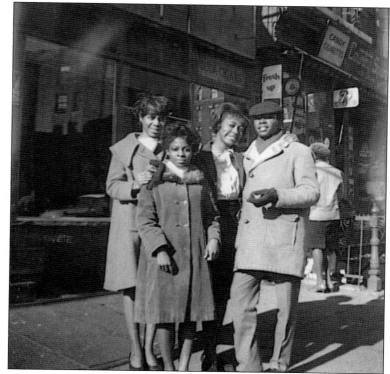

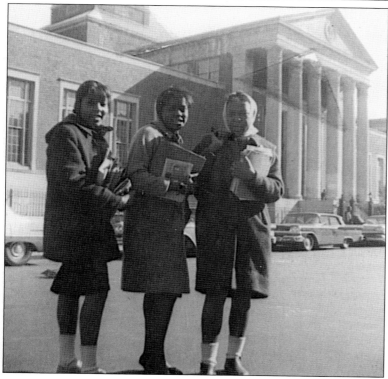

These three young girls pose in front of the Benjamin Franklin High School, located at 114th through 115th Streets and Pleasant Avenue in 1961. The original school opened in 1934 on 108th Street and moved to its present location in 1941. Due to declining enrollment, Benjamin Franklin High School closed in 1982. Today it is the Manhattan Center for Science and Mathematics. (Courtesy of Vickie Beckford.)

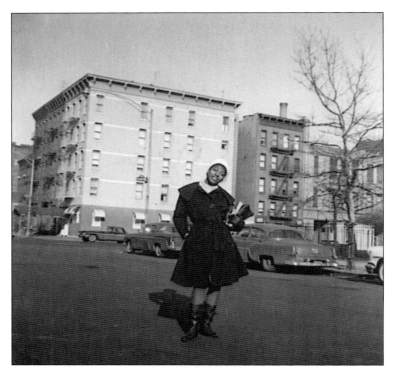

A Benjamin Franklin High School student is pictured in May 1963 on 116th Street and Pleasant Avenue. The weather was unusually cool on this spring day. The old section on "Doctor's Row" was remodeled and replaced by six-story tenements. (Courtesy of Vickie Beckford.)

Seen in May 1963, this Benjamin Franklin High School student proudly wears his school's jacket. He is also carrying his books while he holds a pair of canvas sneakers. The location is 116th Street between Lexington and Third Avenues. (Courtesy of Vickie Beckford.)

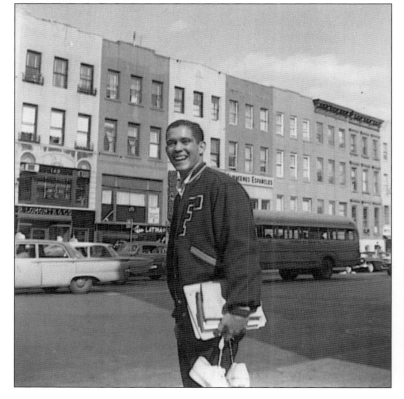

Petrona Feliciano poses with her grandson Dennis Archilla at 104th Street near Madison Avenue in the late 1940s. Many billboards and other advertisements appeared throughout the neighborhood's tenements. An advertisement for the Pontiac can be seen to the left of young Dennis. (Courtesy of Olga Quinones.)

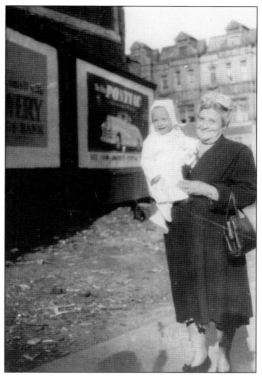

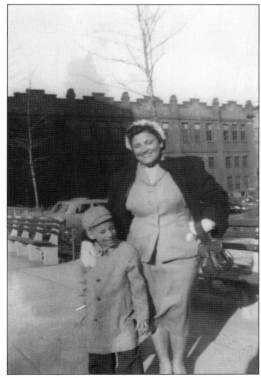

Olga Quinones is seen in the late 1940s or early 1950s with her son Dennis near the old 100th Street Lexington Avenue Bus Depot. (Courtesy of Olga Quinones.)

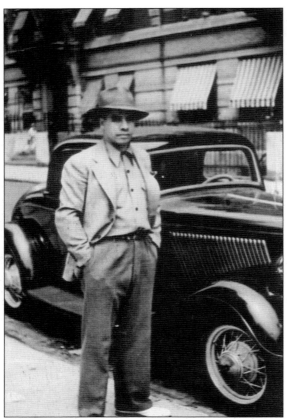

In the 1930s, Victor Velazquez poses in front of his apartment on 114th Street between Second and Third Avenues. Standing next to this classic automobile gives Victor a distinguished look. (Courtesy of Manny Diaz Jr.)

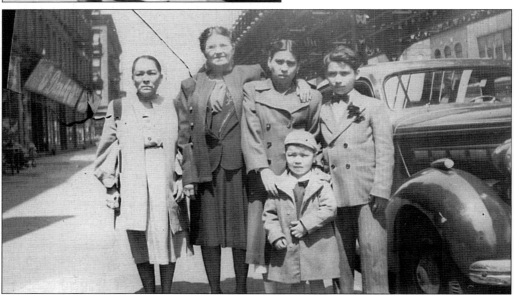

These East Harlemites are seen in their Sunday best on Easter Day in 1947. The location is 109th and 110th Streets and Third Avenue. Pictured from left to right are unidentified, Grandmother Eva, Ana Ferreira, Ramon Ferreira in the bow tie, and Albert Ferreira. (Courtesy of Ramon Ferreira.)

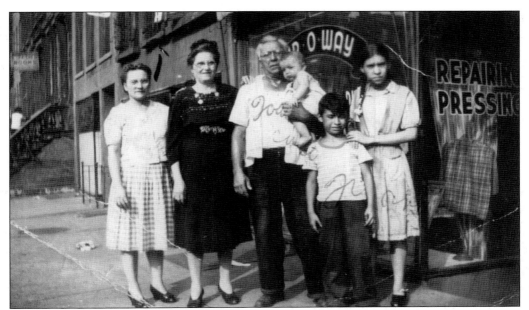

Pictured in 1946 are Ramon Ferreira who this time is with both grandparents and his aunt Ana. His grandfather is holding his younger brother Albert. The location is 109th Street near Third Avenue. (Courtesy of Ramon Ferreira.)

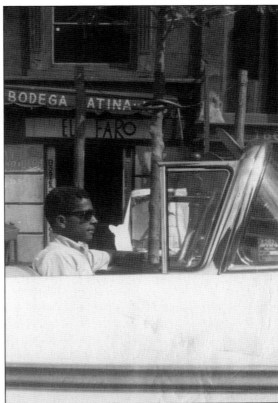

Manny Segarra is seen sitting behind the wheel of a Chevrolet convertible parked on 106th Street and Lexington Avenues. El Faro Latina Bodega (store) is in the distance of this mid-1960s photograph. (Courtesy of Manny Segarra.)

Rev. S. N. Snipes from the Church of the House of Prayer pastors a neighborhood church on 122nd Street and Third Avenue. Reverend Snipes is also the vice chairman of the Boriquen Health Center in East Harlem. The other two people next to Snipes are unidentified.

Wally Lambert is pictured in the mid-1970s standing outside his fruit and vegetable store located on 126 East 103rd Street between Park and Lexington Avenues. Wally is wearing a famous apron that says, "I got my job through the New York Times." (Courtesy of Wally Lambert.)

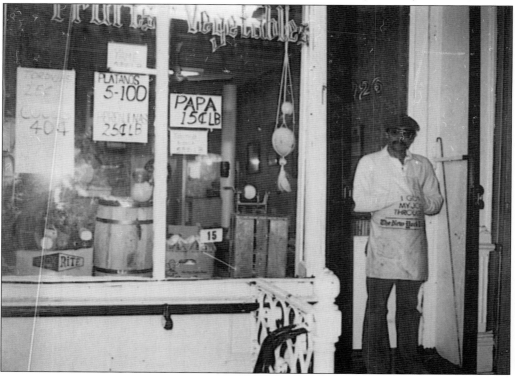

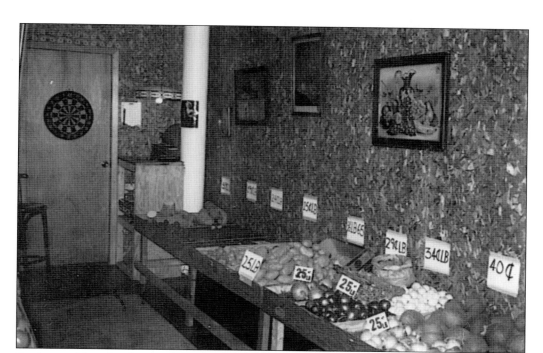

Produce sold at the fruit and vegetable store is on full display in this mid-1970s photograph. Notice the affordable prices for the produce and how the times have changed. (Courtesy of Wally Lambert.)

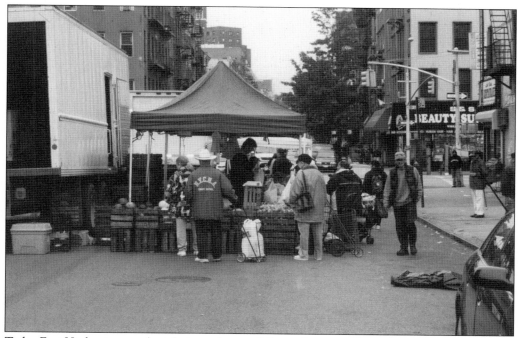

Today East Harlemites can buy their produce at different locations throughout the neighborhood. Here residents shop at an outdoor fruit and vegetable stand located on 104th Street near Third Avenue.

East Harlemites are purchasing tacos from a taco truck. The influx of Mexicans and South Americans into East Harlem in the late 20th and early 21st centuries has kept the East Harlem tradition of a transitional neighborhood. The location is 116th Street and Lexington Avenue.

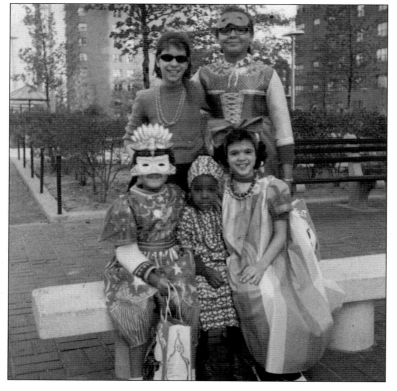

These young East Harlemites are cheerfully displaying their Halloween costumes in 1965 at the Benjamin Franklin Plaza cooperative, which spans 106th to 109th Streets from First to Third Avenues. (Courtesy of Ramon Rodriguez.)

Decades later, East Harlemites continue to celebrate Halloween, but this time the location is 116th Street between Lexington and Third Avenues.

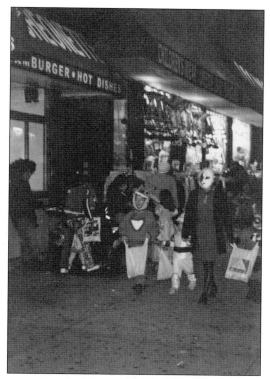

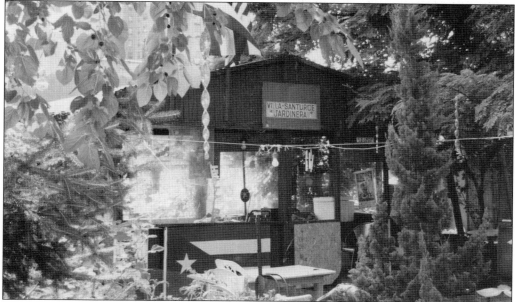

Seen here is Villa Santurce Jardinera. In the 1980s and 1990s, many vacant lots were replaced by neighborhood gardens and *casitas* ("little houses") located throughout East Harlem. In the 21st century, many gardens were demolished to make way for the luxury housing developments. This garden was named in honor of Santurce, a town in Puerto Rico. The location is 111th Street between Madison and Park Avenues.

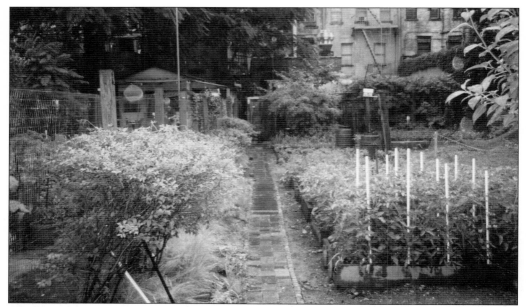

This view shows the inside of the Villa Santurce garden. The lush green leaves transport visitors to a beautiful setting of tranquility. East Harlem, along with the rest of New York, has "gone green." The idea is to promote everything green. This has led to planting trees in the neighborhood to reduce the high asthma rates in East Harlem. Another green initiative is to promote healthier foods by encouraging all East Harlemites to buy fruits and vegetables.

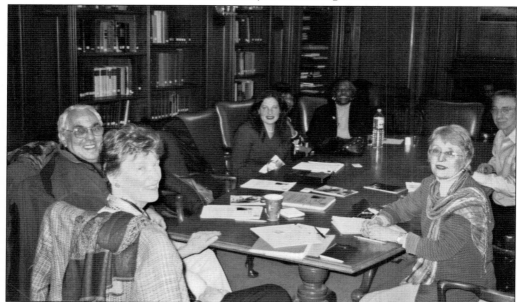

Members of the East Harlem Historical Organization are pictured here. Founded in 1993, this organization has sponsored seminars, book readings, discussions, and events documenting the history of East Harlem. Pictured from left to right are Gina Rusch, Mario Cesar Romero, two unidentified, Laura Johnson, Prof. Gerald Meyer, and Kathleen Benson. The location is the Museum of the City of New York on 103rd Street and Fifth Avenue.

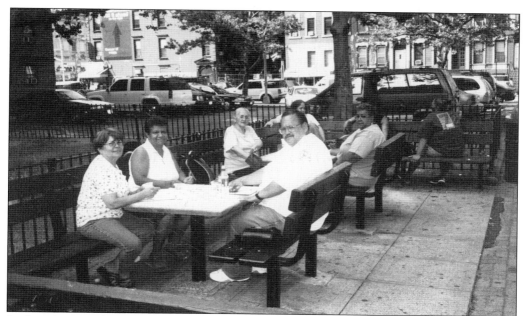

In this photograph, residents are participating in the board game or lottery. Besides dominoes, East Harlemites will play cards or pokeno, a board game used with playing cards. The place is 114th Street between Second and Third Avenues. Pictured from left to right are Wilfredo Cruz, Margarita Sanchez, Gloria Quiles, Nedi Vallines, and Maria Alvarez.

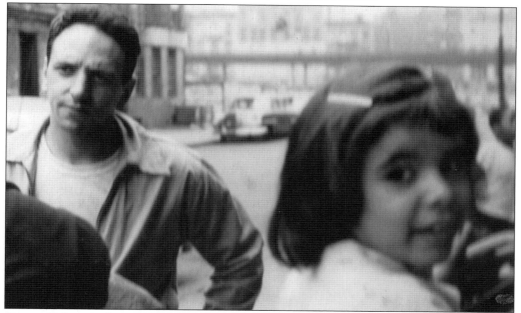

George Calvert is shown in 1955 with several young children near Third Avenue on East 104th Street. Calvert came to East Harlem in 1953 and joined the staff of the East Harlem Protestant Parish. Fifteen years later he founded Hope Community, which, after 40 years, has become the premiere housing redevelopment agency in the neighborhood. To date, Hope Community has rehabilitated over 1,300 apartments. (Courtesy of the Calvert family.)

On his communion day in the 1940s, Ray Grist is decked out in his suit along East River Drive. Ray is the brother of renowned opera singer Reri Grist and an artist in his own right. (Courtesy of Ray Grist.)

Bea Odum stands on her apartment stoop near 101st Street and First Avenue in the early 1940s. (Courtesy of Bea Odum.)

Hortencio and Evelyn Morales are pictured near the 110th Street Lexington Avenue subway. Several small stores can be seen in the background.

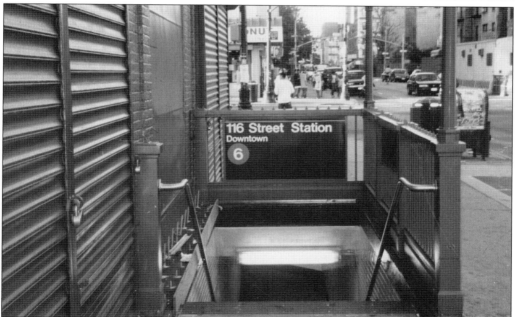

The downtown 116th Street subway station on Lexington Avenue is in this 2005 photograph. The Lexington Avenue subway was built in 1919. To date, it is the only subway on the east side of Manhattan. The Second Avenue subway is currently being constructed, but it is scheduled to open in 2016.

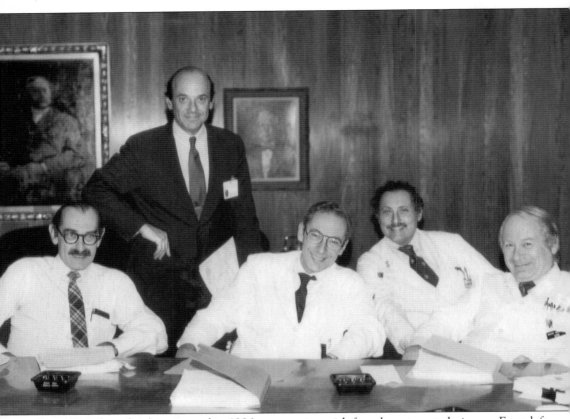

Dean Kase (standing) is pictured in 1986 at a meeting with four department chairmen. From left to right are Dr. Kurt Hirschhorn (pediatrics), Arthur H. Aufses Jr. (surgery), Sherman Kupfer (administration), and Richard Gorlin (medicine). (Courtesy of Mount Sinai Hospital.)

Samuel Rosado stands outside Mount Sinai Hospital near the Klingenstein Clinical Center between Ninety-ninth and 100th Streets and Madison Avenue. To the right are the George Washington Carver Projects.

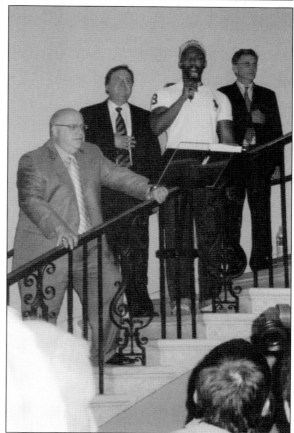

Tim Russert, former moderator of NBC's *Meet the Press*, is pictured in 2007 at the Museum of the City of New York. The museum honored the Golden Age of Baseball in New York City, which spanned from 1947 to 1957. Back then three professional league baseball teams, the New York Yankees, New York Giants, and Brooklyn Dodgers, all played in New York City. From 2003 to 2008, Russert served on the board of directors of the National Baseball Hall of Fame. He was on hand to open the exhibit and is seen during the Pledge of Allegiance, which is being recited by the gentleman to his right. The location is 103rd-104th Streets and Fifth Avenue.

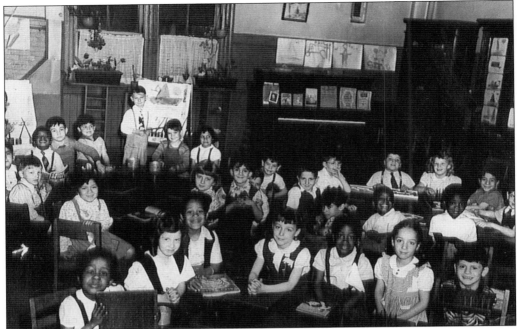

Pictured is the 1949 first grade class at Public School 163. Notice the old-style desks. The boys wore white shirts, ties, and suspenders, while the girls wore dresses. (Courtesy of Bea Odum.)

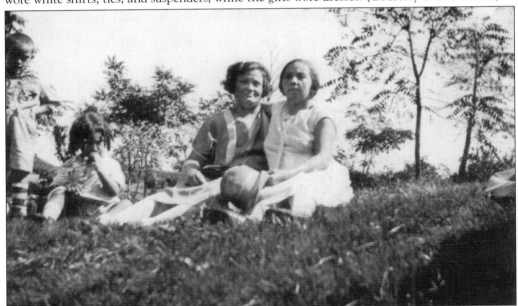

Olga Quinones (second from left) is pictured in 1927 inside Central Park near 104th Street and Fifth Avenue with her mother, Petrona Vega (third from left); her brother Johnny (standing, far left); and Rose Librada, who is pregnant with her second child. Central Park, built in 1859, is located from Fifty-ninth to 110th Streets and between Fifth and Eighth Avenues. The place is an oasis for many New Yorkers who wish to leave the city's streets. Many New Yorkers can take in the green grass, lakes, and playgrounds, or sunbathe on the great lawn. (Courtesy of Olga Quinones.)

Lena Feliciano poses with an unidentified friend in Central Park near 105th Street and Fifth Avenue in 1940. (Courtesy of Olga Quinones.)

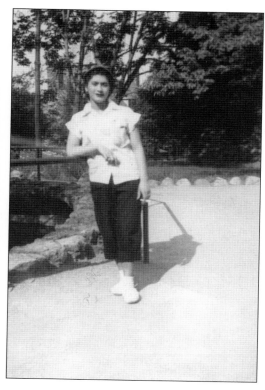

Carmen Rodriguez Rivera Hayes is shown in 1955 in Central Park leaning on a rail. She is holding a cigarette in her right hand. The location is 104th Street and Fifth Avenue. (Courtesy of Olga Quinones.)

East Harlem's stickball team is pictured in the 1980s on 115th Street and Madison Avenue. Stickball was played throughout many East Harlem Streets, with the most popular years being from the mid-1920s to the 1950s. All that is needed to play the game is a broomstick, Spalding ball, and a few players. Stickball is still played in East Harlem on the weekends near 109th Street between Second and Third Avenues.

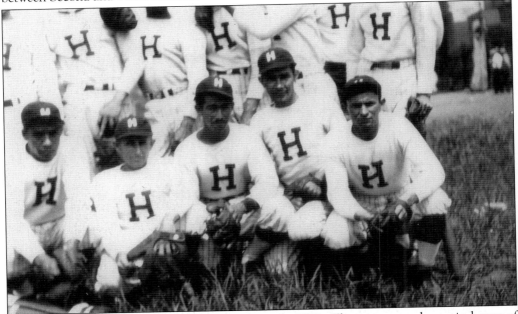

The Humacao baseball team is pictured in the early 1930s. The name was chosen in honor of Humacao, a town in Puerto Rico. The location is a vacant lot on 108th Street and Madison Avenue. (Courtesy of Manny Diaz Jr.)

Decades later, baseball is still played in East Harlem through the East Harlem Little League. Though children have replaced the adults on the diamond, the East Harlem Little League and the Harlem RBI continue to train the next generation of baseball players. The location is between 111th and 112th Streets and Madison and Park Avenues.

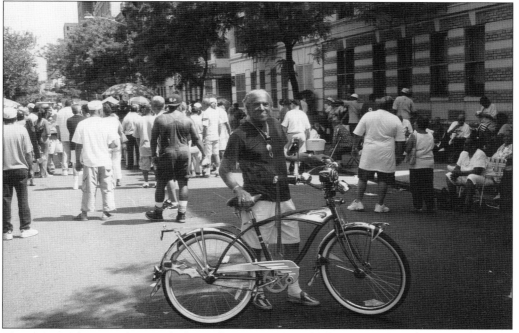

This East Harlemite is known for his collection of old-fashioned bicycles. He is seen displaying his golden gems at the Old Timer's Stickball celebration on 111th Street between Madison and Lenox Avenues.

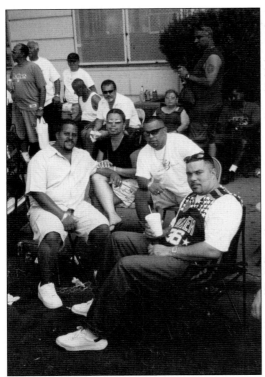

In 2004, William and Rachel Rosario join Jerry Aguilar and Robert Escobar, drink in hand, at the Old Timer's Stickball celebration. Many former East Harlemites travel as far as California or Puerto Rico for the reunion.

This is a future quarterback for the New York Giants or Jets. This East Harlem youth is in the process of throwing a football in the mid-1960s. Back then many East Harlemites played on the streets because there were not too many cars in the neighborhood. Automobile ownership increased after World War II, and many children took to the sidewalk to play their games. The location is 104th Street between Lexington and Third Avenues. (Courtesy of Manny Segarra.)

Playing dominoes is a time-honored tradition among many East Harlemites. During the spring and summer months, East Harlemites will set up a small table and folding chairs on the sidewalk and play dominoes. Checkers or card games are the other forms of entertainment that take place at a local neighborhood clubhouse. The location is 104th Street between Park and Lexington Avenues.

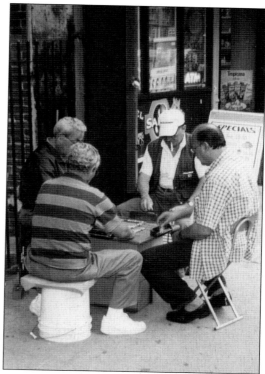

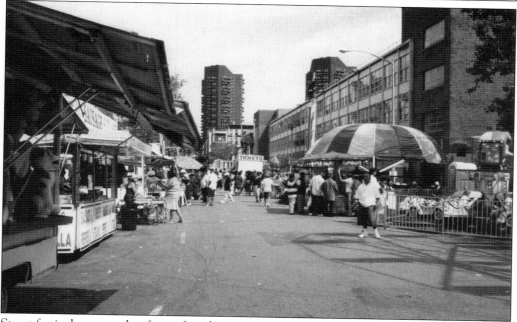

Street festivals are another form of outdoor entertainment during the summer. Many youngsters enjoy riding the carousel, while adults (right) try to win a stuffed animal for their loved ones. A few feet away, a customer is talking to a sales woman about purchasing an item. The location is 109th Street between Second and Third Avenues.

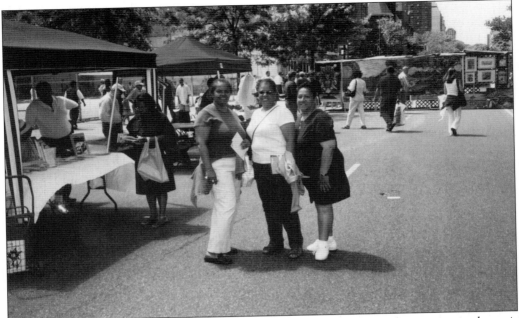

Gladys Rivera and friends are seen at the 2003 festival. In the background, a prospective buyer is looking at a book for a possible purchase. Other local vendors have also displayed their artwork for the public to view.

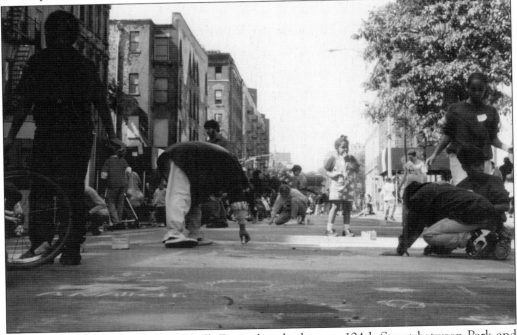

The First Annual East Harlem Chalk Festival took place on 104th Street between Park and Lexington Avenues in 1994. Here East Harlem youth design their artwork on the streets. Grupo Tizon first sponsored this event, which today has been maintained by Hope Community. (Courtesy of Manny Segarra.)

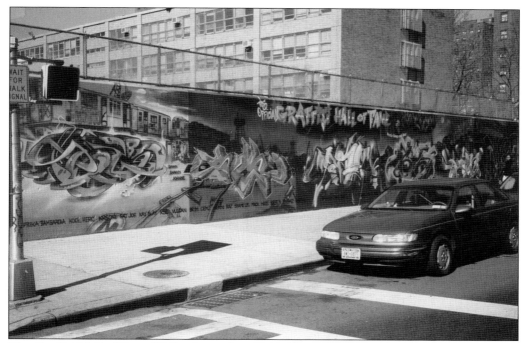

The Graffiti Hall of Fame Wall is located on 106th Street and Park Avenue next to the former Junior High School 13, today the Jackie Robinson Complex. Each year, new artwork is added to the wall, and after its completion, the wall will feature a new design and bright colors.

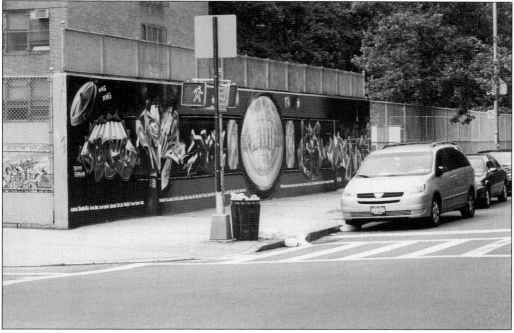

In 2004, the Graffiti Hall of Fame Wall's new design resembles a championship belt. In the top left corner is a spaceship. Each year, Tat's Crew does the design and artwork.

119

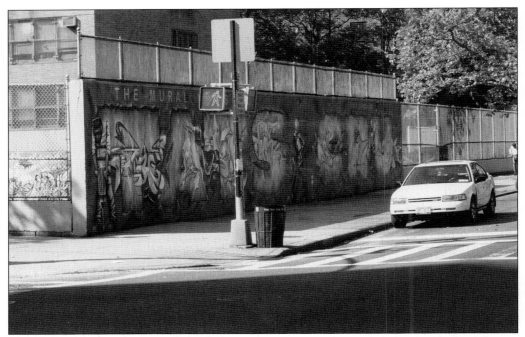

Another year later, the Graffiti Hall of Fame Wall artists Tat's Crew dispensed with the elaborate designs and colors. The organization simply informed everyone that their art work appears on this wall.

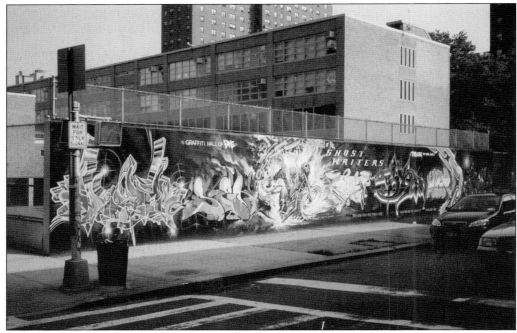

Tat's Crew returned to the original form of artwork. On the left is the Graffiti Hall of Fame. The center image of a skeleton on a motorcycle is called "Ghost Writers." This pays homage to the Marvel comic book character Ghost Rider.

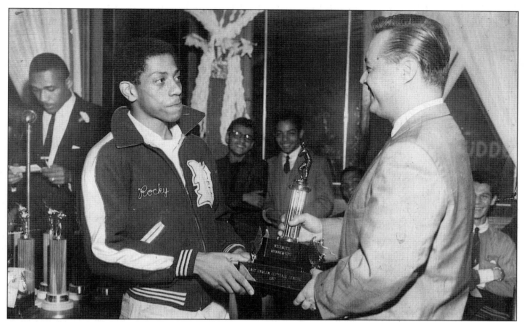

In 1957, Viceroys gang member "Rocky" Torres is receiving a trophy, as his team finished in second place in the East Harlem Softball League. The Viceroys were one of the many neighborhood street gangs in East Harlem. Many adolescents and young adults throughout East Harlem formed gangs to protect their turf or to bond with other adolescents. In some instances, the gang became a surrogate family, and many were nonviolent or were singing groups. These gangs included the Dragons, Red Wings, Condemners, Comanchees, Copians, Untouchables, Diplomats, and Turbins. (Courtesy of John Torres.)

Members of the Viceroys pose for a picture in an East Harlem apartment in the 1950s. From left to right are Alberto Torres, his cousin Chickie ?, and unidentified. Back in the 1940s and 1950s, many gang members dressed as if they were part of an Ivy League school and wore colorful sweaters, jackets, and derbies. (Courtesy of John Torres.)

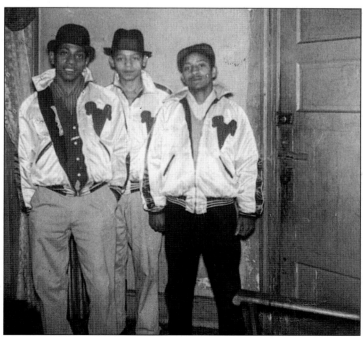

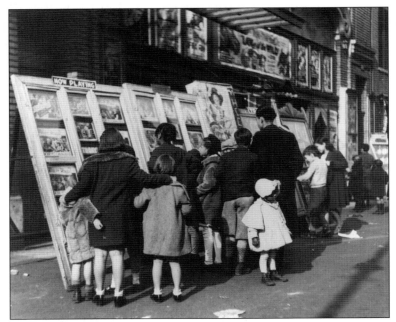

Neighborhood movie advertisements were used to entice the public to see a movie at their local theaters. Children are pictured viewing the movie advertisement in 1930. The location is 110th Street and Madison Avenue. (Courtesy of Ilona Albok Vitarius; photograph by John Albok.)

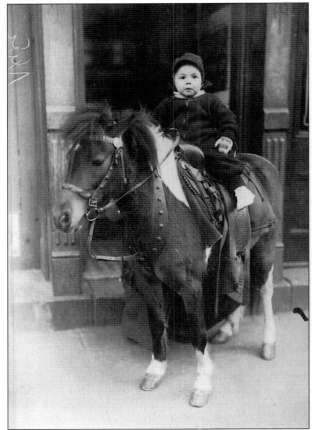

Young Wally Lambert is seated atop a pony in the late 1940s. In East Harlem, many young toddlers and children took their first photographs on the pony. The location is 104th Street near Third Avenue. (Courtesy of Wally Lambert.)

Helen (last name unknown) takes her turn on the pony while her friend Butch is holding the stirrup in 1949. The location is 104th Street near Lexington Avenue. (Courtesy of Manny Segarra.)

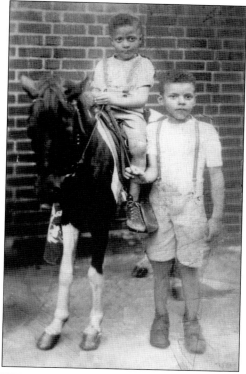

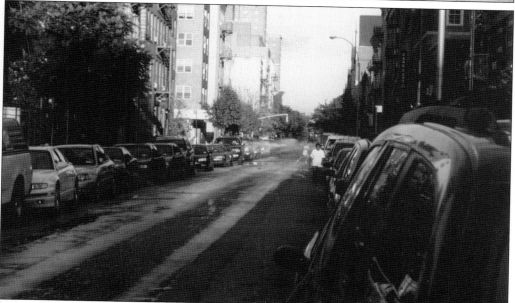

East Harlemites are seen cooling off in front of an open hydrant. Years ago, East Harlemites would turn on the fire hydrant and take an empty can and scrape the sides of the can until both lids came off. With the water coming out of the hydrant at full blast, the can was placed in front of the nozzle. The person who held the can controlled the water and could make it turn it left or right. The location is 105th Street between Second and Third Avenues.

Here is the refurbished El Museo Del Barrio. El Museo Del Barrio first opened in 1969 as a children's museum. It moved throughout several locations in East Harlem before finally settling on Fifth Avenue between 104th and 105th Streets. In 2007, El Museo Del Barrio underwent a renovation. It reopened in 2009.

Christmas has arrived in East Harlem as this young child receives several presents from Santa Claus on 106th Street and Third Avenue.

Santa Claus seems to be a popular character, posing with police officers on this cool evening. The officer on the right is deputy inspector David Colon of the 23rd Precinct.

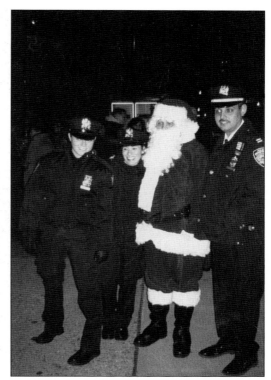

Pictured is the 2005 Christmas tree sponsored by the East Harlem Board of Tourism. The lighting of the tree has become an annual tradition in East Harlem, as local residents and politicians view the celebratory event. The location is 106th Street and Third Avenue.

Metropolis Studio, which originally began as the Pathe Studio in 1946, is seen in this 2005 photograph. The studio's television equipment is completely digital, and the studio provides a greenroom, private dressing room, and make-up and hair rooms. Black Entertainment Television's (BET) *106 and Park* began their run at the studio. Singer Mariah Carey and television personality Emeril Lagasse are just some of the artists that have worked at Metropolis Studio. The location is 106th Street near Park Avenue.

Hope Community's the Spirit of East Harlem Wall is pictured in 2005. Hank Pussing created the original artwork in 1978 with the assistance of Manny Vega with contributions from the New York State Council of the Arts. Manny Vega restored the mural in 1998 with financial assistance by Citibank and Chase Manhattan Bank.

BIBLIOGRAPHY

Aufses, Jr. Arthur H. and Barbara Niss:. *The House of Noble Deeds—The Mount Sinai Hospital 1852–2002*. New York University Press, 2002.

www.baseballreference.com (Lou Gehrig)

www.brosociety.org (Eddie Palmieri bio)

Jacobs, Jane. *The Death and Life of Great American Cities*. New York: Random House, 1961.

Meyer, Gerald J. *Vito Marcantonio-Radical Politician, 1902–1954*. New York: State University Press, 1989.

Mills, Rodney H. "An American Ship Line: The Porto Rico Line." *Steamboat Bill*. No. 23. Fall 1997: 173–187.

www.newyorktimes.com (Ed Sullivan obituary, October 14, 1974)

Orsi, Robert Anthony. *The Madonna of 115th Street: Faith and Community in Italian Harlem*. New Haven: Yale University Press, 1985.

www.arcadiapublishing.com

Discover books about the town where you grew up, the cities where your friends and families live, the town where your parents met, or even that retirement spot you've been dreaming about. Our Web site provides history lovers with exclusive deals, advanced notification about new titles, e-mail alerts of author events, and much more.

MADE IN THE USA

Arcadia Publishing, the leading local history publisher in the United States, is committed to making history accessible and meaningful through publishing books that celebrate and preserve the heritage of America's people and places. Consistent with our mission to preserve history on a local level, this book was printed in South Carolina on American-made paper and manufactured entirely in the United States.

This book carries the accredited Forest Stewardship Council (FSC) label and is printed on 100 percent FSC-certified paper. Products carrying the FSC label are independently certified to assure consumers that they come from forests that are managed to meet the social, economic, and ecological needs of present and future generations.

FSC
Mixed Sources
Product group from well-managed
forests and other controlled sources

Cert no. SW-COC-001530
www.fsc.org
© 1996 Forest Stewardship Council

Find *Your* Place in History.